CELTIC
AND ANGLO - SAXON PAINTING

CELTIC

AND ANGLO-SAXON PAINTING

BOOK ILLUMINATION IN THE BRITISH ISLES 600-800

CARL NORDENFALK

Chatto & Windus London

First published in the UK in 1977 by
Chatto & Windus Ltd., London

ISBN 0 7011 2242 0

Printed and bound in West Germany by Mohndruck, Gütersloh

CONTENTS

ACKNOWLEDGEMENTS

The author and publishers would like to express their sincere thanks to the following institutions and individuals who kindly provided materials and granted permission to reproduce them in this volume.

COLOR PLATES

DUBLIN, The Board of Trinity College Dublin, Plates 2, 3, 4, 5, 6, 7, 8, 39, 40, 41, 42, 43, 45, 46, 47, 48 (Photo, The Green Studio Limited, Dublin).

DURHAM, The Dean and Chapter of Durham Cathedral, Plates 1, 13, 14, 27, 28.

LICHFIELD, The illustrations from the Lichfield Saint Chad's Gospels are reproduced by permission of the Dean and Chapter of Lichfield, Plates 23, 24, 25, 26 (Photo, A. C. Cooper Ltd., London).

LONDON, Reproduced by permission of the British Library Board, Plates 15, 16, 17, 18, 19, 20, 21, 22, 32.

PARIS, Bibliothèque Nationale, Plates 9, 10, 11, 12 (Photo, Bibliothèque Nationale Paris).

STOCKHOLM, Kungliga Biblioteket (Royal Library), Plates 33, 34, 35, 36, 37, 38.

TRIER, Domschatz, Bischöfliches Generalvikariat, Plates 29, 30, (Photo, Ann Münchow, Fotografin, Aachen); Plate 31 (Photo, Verlag D. Thomassin, Trier).

BLACK AND WHITE FIGURES

DUBLIN, Royal Irish Academy, Figure II.

DUBLIN, The Board of Trinity College Dublin, Figure I.

DURHAM, The Dean and Chapter of Durham Cathedral, Figure IV.

FLORENCE, Biblioteca Laurenziana, Figures VII, VIII, X.

LAUSANNE, Urs Graf Verlag, Figure VI.

LONDON, Reproduced by permission of the British Library Board, Figure V.

MILAN, Castel Sforzesco, Figure XI.

PARIS, Bibliothèque Nationale, Figure VIII.

INTRODUCTION

In the history of civilization there can scarcely have been a more fundamental change than from prehistory to historic times—from an age of oral tradition only, to one of written records. If we were to select one object as particularly indicative of those historic centuries, it would certainly be the book. In Greek and Roman antiquity, books were indispensable vehicles for texts of many different kinds, yet they were hardly more. With Christianity, however, one text received an importance far greater than any other. This text was the Gospels, documenting in four ways, complementary to each other, the life and the teaching of Christ. As a consequence the book containing it became an object of unprecedented value—the Book of Books.

As Christianity grew into a world-embracing religion, it spread also across the English Channel, reaching, according to Tertullian, even further north than the Roman legions. No doubt Christians living in the Roman society of England had their holy books, but of them nothing remains; quite likely they all disappeared after the withdrawal of the Romans, followed as it was by the invasion of the pagan Teutonic tribes. Only when Ireland and, a century or two later, England were opened up to new waves of Christian proselytizing did the writing of books take root there for good. Eventually it resulted in a production of those richly decorated manuscripts which, more than anything else, illuminate the "Dark Ages."

However great the fervor of the inhabitants of the British Isles in accepting the Christian message, they were not prepared to give up their old civilization overnight. The Christian missionaries had been taught to proceed with care. Far from lacking cultural resources of their own, the natives possessed a highly accomplished prehistoric art, which was chiefly decorative, and unlike their pagan idols, it was of no evident danger to the new faith. On the contrary, it could be put to a new use by the artisans now serving the Church as they once had served the pagan chieftains. And among the ecclesiastical objects particularly worthy of decoration were the Gospel manuscripts, destined to take their place on the altar during the divine service as its foremost adornment.

The book, the principal tool of an "historic" civilization, thus became the transmitter of an art which preserved its essentially "prehistoric" character. It would have been natural if, in this incongruous compound of two different levels of culture, the higher one had subdued the lower. Yet quite the opposite occurred. Rather than suppressing the artistic traditions of the people it came to redeem, the new religion had a vitalizing influence on them. As if realizing that its days were numbered, and seized therefore by a desire to vindicate its value to the very last, the native art of the Celts and Anglo-Saxons emerged even richer than before in

its closing Christian phase, its greatest masterpieces being the Gospel Books. At the same time the very process of writing changed from a simple means of communication to something almost talismanic, by being combined with ornament— a totally new and persuasive concept of the book which was to prove fruitful all through the early Medieval centuries.

The seed was first sown on Irish soil. Ireland's conversion, traditionally ascribed to Saint Patrick, occurred about the same time as England relapsed into paganism. However, it was only in the sixth century that the form of Christianity which was to be most influential, monasticism, became firmly established in Ireland. It turned the island into a country of scribes at a time when there were as yet none in England. Copying the half-uncial script of the Late Antique codices that had reached them from the Continent, the Irish monks developed a national *scriptura Scottica,* or Insular script as we now prefer to call it, since it was also adopted by the English. The earliest surviving specimens show it in use from at least the end of the sixth century.

There are many more or less legendary tales about the fervor of the Irish devoting themselves to scribal work. Most famous is the story of Colum-cille, the future Saint Columba, furtively copying a (pocket?) Gospel Book in the possession of a fellow believer. The embroilments to which this gave rise ultimately ended in Columba leaving his native country. In 563 A.D. he settled as an "exile for Christ" on a windswept island to become known as Iona, off the Scottish coast. Seized by a call to convert the heathen population of Scotland, the Picts, he established a monastery in Iona with the permission of the King of Dalriada, to whose territory the island belonged.

But in settling on the west coast of Scotland, Columba did not turn his back forever on his homeland. The monasteries he had founded there before his departure remained under his supremacy. It is even said that on one occasion he was called on to adjudicate whether the poets in Ireland should be allowed to continue composing vernacular songs, to which he answered in the affirmative—an example of the perseverance of pagan tradition in literature as well. Of greater importance, however, was the new orientation which the foundation of Iona gave to Celtic monasticism in general. Its missionary aspirations eventually were directed not only to the Picts, but also to those fertile territories south of the Scottish highlands that had been occupied by the heathen Anglo-Saxons.

In that endeavor the Irish were not without competitors. The very year Columba died, missionaries landed in the South of England, sent by Saint Gregory from Rome. Their leader, Augustine, founded the first English archbishopric at Canterbury, the primacy of which remained undisputed. Once firmly established in Kent, the Roman form of Christianity obtained a footing also in the north by the marriage of a Kentish princess to Edwin, the King of Northumbria. Her chaplain, Paulinus, succeeded for a time in winning the population over to the new faith. Yet a pagan reaction checkmated his efforts. It cost Edwin his life and forced his wife and Paulinus to return to the south.

After Edwin's death the legitimate heir to the Northumbrian throne was Oswald who, with his brother Oswy, lived in exile in Iona, where they were educated in the spirit of Saint Columba. Having reconquered his kingdom in 634 A.D. in a

battle fought under the sign of the Cross, Oswald wanted his own subjects to embrace the Christian faith, and with this in mind he invited Aidan, a monk and bishop from Iona, to found a new monastery on the east coast of his realm. The place chosen was the island of Lindisfarne, not far from the king's own residence at Bamborough. In his *Ecclesiastical History of the English People,* Bede has much to tell about the trusting cooperation between Oswald and Aidan. As a final result Oswald was declared a saint after he fell in battle against the pagan king of Mercia. And for another twenty years, during the long reign of his successor Oswy, the Northumbrian church, with Lindisfarne as its spiritual center, retained its allegiance to Iona.

But there was also the church of Rome, and once a number of young and wealthy Anglo-Saxons had gone to Italy for instruction, a crisis became unavoidable. The Irish and the Roman churches differed radically in certain fundamental usages. One was the different positions taken by the two churches on the method of calculating the date for the celebration of Easter; another was the proper form of tonsure. The Roman stand gained a particularly eager champion in Wilfred, a noble Anglo-Saxon youth who, in spite of having been educated at Lindisfarne, became convinced of the inadequacy of the Irish position. In a synod held at Whitby in 664 A.D. under the auspices of King Oswy, he challenged Colman, the third abbot of Lindisfarne, to a disputation and won. As a consequence Colman retired with his Irish monks to Iona, and Lindisfarne was taken over by Northumbrian monks. Yet the spirit of the Columban church was too deeply rooted in Anglo-Saxon soil to die completely. So little did the new native abbots of Lindisfarne oppose it that they almost deliberately followed the life-style of their Irish predecessors. To mention only the most famous of them, Saint Cuthbert acquired his reputation for holiness by retiring, like an Irish cenobite, to the most rugged of the Farne islands, where he died of self-enforced hardship.

In 685 A.D. Oswy's warlike son, Ecfrith, fell in the battle of Nectansmere against the Picts, and was succeeded by his half-brother Aldfrith, whose peaceful reign lasted twenty years. A man of scholarly inclination, he too spent a great many years on Iona studying with its Abbot Adamnán before ascending the throne. If, as seems likely, the Book of Durrow dates from about 680, Aldfrith may well have seen it written in Iona; in fact, the presence there of a Northumbrian prince would best explain the non-Irish elements in this key manuscript.

In the early years of Adamnán's abbacy, Iona must have been a place of great cultural vigor. Aldfrith was not the only distinguished guest; a French pilgrim returning from the Holy Land, a bishop by the name of Arculf, was driven by a storm to the Scottish coast and found a refuge on Saint Columba's island. Based on his testimony, Adamnán wrote a book, *De locis sanctis,* about the sanctuaries in the Near East, which he illustrated with ground plans of the monuments based on sketches that Arculf had made on a wax tablet—as good a proof as any that at this time the art of book illustration was practiced in Iona. The venerable pilgrim's visit was all the more welcome in that it enhanced Iona's prestige: if Wilfred had carried off his victory by invoking Saint Peter, whose tomb was in Rome, the Irish could now boast a direct connection with the sepulchre of Christ. Adamnán was not slow in having his book disseminated in Northumbria as well. He took a copy with him when, in 686, he went on an official embassy to his friend, King

Aldfrith. On the same occasion, or during a second trip to Northumbria two years later, he also paid a visit to the stronghold of the Roman party, the double monastery of Wearmouth and Jarrow; there he made the acquaintance of Abbot Ceolfrith, who later claimed in a letter that he had converted his guest to both the Roman Paschal reckoning and form of tonsure.

On his return to Iona, Adamnán actually tried to win his own monks over to the Roman usage, but in this respect he was more successful with the Columban foundations in Ireland proper. There he had an ally in Egbert, a pious Englishman living in self-chosen exile in an as yet unidentified place called Rathmelsigh. It was Egbert who later succeeded in also breaking the last resistance of the monks of Iona. Filled with the missionary zeal of the Irish church, Egbert sent his countryman and pupil Willibrord to convert the pagan Frisians. This took place in 690 A.D., which must also be the date of the still extant Gospel Book, which Willibrord probably had with him when he left.

In 698 A.D. Saint Cuthbert's bones were transferred to a reliquary shrine, and in connection with this, or shortly afterwards, a great Gospel Book was written and illuminated in his honor. As a later but trustworthy inscription tells us, its author was Eadfrith, bishop of Lindisfarne from 698 to 721. It has been suggested that he might be identical with a certain Ehfrith to whom Aldhelm of Malmesbury wrote about 686, congratulating him on his return from a six years stay among the Irish. The identification is far from certain, but if correct, it would best explain the character of the Book of Lindisfarne—a work primarily in the Celtic tradition, although executed by an Anglo-Saxon artist with close relations to Jarrow-Wearmouth.

The Gospels of Saint Willibrord and the Book of Lindisfarne, the most perfect of all the Hiberno-Saxon manuscripts, embody, together with the Books of Durrow and Kells, a national style common to Ireland and Northumbria. The Italianizing trend sponsored by Jarrow and Wearmouth never equaled it in importance, even though it had the famous *Codex Amiatinus* to its credit (Fig. X). And if, as seems likely, the Durham *Cassiodorus in Psalmos* was written and decorated at Jarrow in the time of Bede, the Celtic manner of decorating manuscripts was not foreign even to this scriptorium.

This Janus-faced mode of book illumination, characteristic for the Northumbrian centers, eventually spread to the south of England as well. There, in Canterbury, it infused new life into the tradition stemming from the books brought to England by Saint Augustine's mission. The chief monuments of this revival are the so-called Vespasian Psalter, now in the British Library, and the Stockholm *Codex Aureus*—a manuscript so splendid that it suggests royal patronage. We would be better informed about this new chapter in the history of Insular book illumination were it not that Bede's *Ecclesiastical History* ends shortly before the emergence of Canterbury as a leading school under Northumbrian influence. At that time the see of Canterbury had as primate Nothelm, who, before becoming archbishop, had maintained close relations with Northumbria, supplying Bede with most of his information concerning the history of the Roman mission to England. Indeed, it seems fitting that this successor, Cuthbert (740–758), who would have watched the *Codex Aureus* being written, bore the name of the great Northumbrian saint.

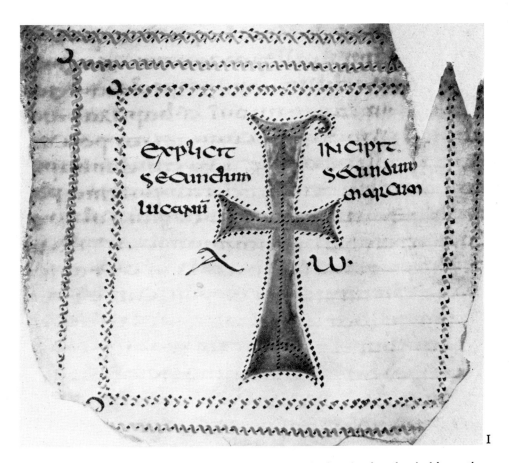

I

Even earlier, Hiberno-Saxon book illumination had gained a foothold on the Continent, in the monastery founded by Saint Willibrord at Echternach where, among other books in the Insular style, the Gospels of the Cathedral Treasury of Trier was produced. The Insular style practiced in this and other abbeys founded by Anglo-Saxon missionaries eventually exercised a fertilizing influence on the great revival of the arts which was the outcome of Charlemagne's cultural policy. Even in the heyday of Carolingian Classicism under Charles the Bald, one of the leading schools, usually called the Franco-Saxon, held tenaciously to the ornamental vocabulary of Insular book decoration. In fact, the influence of this late flowering was powerful enough to be felt all over Europe well into the early Romanesque period.

By localizing in Northumbria all those key manuscripts that show the Hiberno-Saxon style of book decoration in full maturity, some modern scholars have gone so far as to deprive Ireland of the honor of having played an essential part in the creation of what has been considered its greatest national exploit. *Essai sur la miniature d i t e irlandaise* is the challenging title of a book by a Belgian scholar, François Masai, which appeared shortly after World War II. The weakness of its argument, however, is that it fails to recognize the modest but undoubtedly Irish origin of the development in question.

Among the earliest specimens of Irish script still preserved in Ireland is a sadly mutilated copy of the pre-Jerome version of the Gospels. The *Codex Ussher-*

a.

b.

c.

II

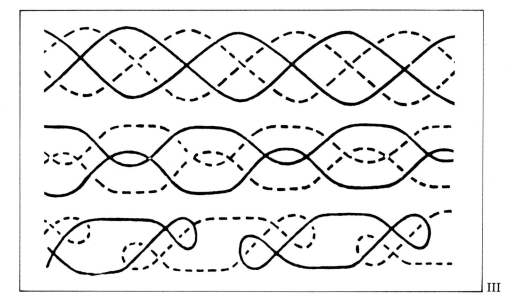

III

ianus Primus, as it is called after its seventeenth-century owner, Archbishop James Ussher, is now in Trinity College Library, Dublin. Written around 600 A.D., it lends support to Masai's view in that it confirms that Celtic book decoration had not yet acquired a distinctive character at that time. On one page, the titles marking the transition from Luke to Mark (the Old Latin order) are adorned by a monogram cross in silhouette within a wide frame made up of three rows of alternating brown strokes and red dots, much like the colophon ornaments which the scribes of old were accustomed to draw without lifting the hand from the parchment (Figure I). The red dotting around and on the cross, as well as the accentuation by projecting "horns" of the corners of the frames are the only faint adumbration of what was to follow in book ornament.

It is otherwise with the next step in the development, represented by the so-called *Cathach of Saint Columba* in the Royal Academy of Dublin. Some sixty decorative initials survive, and here we recognize for the first time a calligraphic inventiveness entirely different from any previous attempt at combining script and ornament (Figure II). Instead of standing apart from the body of the text the initial is, as it were, drawn into it, the subsidiary letters also being treated as display characters, but on a gradually decreasing scale. This "diminuendo" effect was an invention which from now on was to remain a constant in Hiberno-Saxon book decoration.

As to the initials themselves, they are conceived as elastic forms expanding and contracting with a pulsating rhythm. The kinetic energy of their contours escapes into freely drawn appendices, a spiral line which in turn generates new curvilinear motifs or a jet of alternating curves and dots—scribal ornaments which are already to be found in the *Codex Ussherianus.* Occasionally the letters end in an open-mouthed animal head. The appendices are most often located in the letters' open interstices, spaces that in the continuous development of the Medieval initial were to remain the chief *Lebensraum* for the purely ornamental components.

In their free rhythmic play on resilient spirals and curves, the initials are linked to the still lingering tradition of Celtic La Tène art. Parallels can be found in Ire-

land in both metal work and stone carvings. In the *Cathach* the art of book decoration has turned away from the Late Antique paradigms and adopted the native vocabulary. The scribe who invented this type of initial may not have been a great artist, but he took a step in a new direction of extreme importance for the future. Since the most plausible date for the *Cathach* is around 625 A.D., it occurred before any books were as yet written in Northumbria.

Around the middle of the seventh century a step forward was brought about by contact with a new type of ornament: interlace. This decorative motif is commonly believed to have been imported directly from Egypt. The fact that we find some of its most developed forms in Coptic art is not, however, a decisive argument. There were similar trends in Byzantine and Italian art. In England a skilled use of interlace combined with animal ornament is to be found on certain objects from Sutton Hoo, now dated as early as the first quarter of the seventh century.

Interlace is primarily a filler ornament, which lends itself especially to being poured, as it were, into the middle groove of a border. This, in fact, is how it first appears in Insular book decoration, namely on the colophon page at the end of Saint Matthew in the remains of a Gospel Book or New Testament now divided up between three codices in Durham Cathedral Library. The frame has the unusual shape of three *D's* piled one on top of the other, and the new type of filling has been amply used in the decoration (Plate 1).

Interlace is not a motif that can be learned by simply looking at a model. One must know the "trick," and from unfinished interlace borders we can tell how it was usually made up. The designated area was first marked alternately with three or two dots, like the "bull's eye" on a domino eight-spot. To construct a regular four-band braid, as in the lowest *D* of the Durham colophon page, all the artist had to do was to fill the intervals outside and between the dots with ribbons passing alternately over and under each other. This procedure almost mechanically gives rise to two pairs of undulating bands crossing each other in symmetrical waves, as we see in the diagram (Figure III). In the middle *D* another four-strand twist of similar construction has produced a somewhat different design. In the upper *D* a third variant has been tried, most easily deciphered in the curved part of the border. Here regular "breaks" divide the ribbons into two interlocking loops that turn back on themselves. The finished design is an early example of a new virtuosity on the part of the Insular artists, who were soon to surpass their Continental masters in the handling of interlace ornament.

In the spandrels of the *D's,* more robust ribbons catch the eye. In certain parts the open spaces between them are wide enough to allow the structural "bull's eyes" to show up as elements in the design. The course of the ribbons is intentionally obscured by changes in coloring—again ultimately a Late Antique device, but handled here with a particularly fine sense of effect by the Insular artists.

Ribbons of the same broad dimension occur in the monogram initial *INI* at the beginning of the Gospel of Saint Mark, which fortunately has also been preserved (Figure IV). Left free and ending in animal heads similar to those in the *Cathach,* they form a figure-eight pattern to replace the slanting bar of the *N*. The regular circles described by their loops have clearly been drawn with the aid of a compass. This is also true of the curved backs of the *D's* in the colophon frame, and there the straight contours betray the use of a ruler. This is the first instance

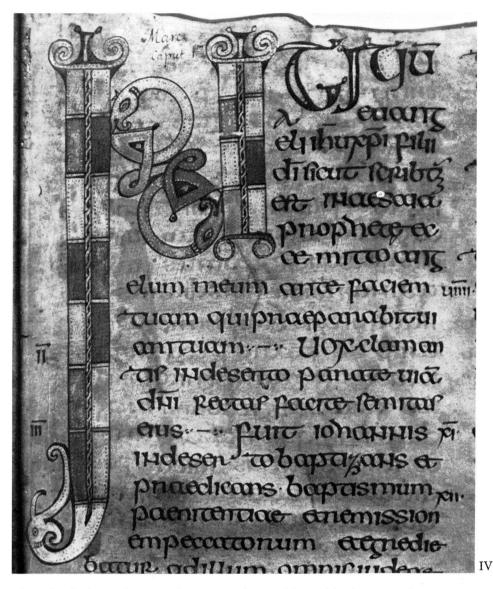

IV

where book decorations can be seen to be working with these two instruments, which in the future were to be used with growing inventiveness.

In spite of its advance over the *Cathach*, the Durham fragment is still but a prelude. Only with the Book of Durrow, the oldest of the completely preserved Gospel manuscripts, does the great epoch begin. Almost overnight an essentially anti-Classical style was brought to near perfection. So sure of their intentions were the artists that they were able to transform radically whatever foreign models came within their orbit, and so deep-rooted was the style that in Ireland, at least, it was to last for more than three centuries.

Most of the Hiberno-Saxon manuscripts are recognizable by the "feel" of their membranes. They have a suede-like surface highly receptive to ink and color. At one time this texture was thought to be a peculiarity of calfskin as distinct from sheepskin, the normal type of parchment used elsewhere. However, it is now recognized that it is the result of the way the hides were prepared. In fact, the

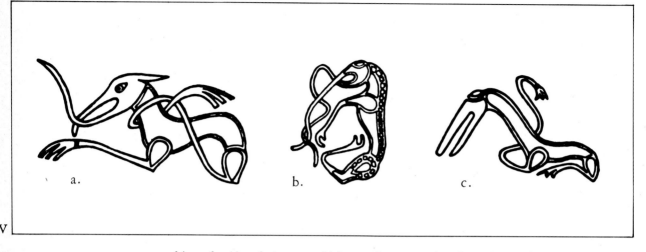

a. b. c.

V

skins of calf and sheep could be used more or less interchangeably in one and the same manuscript.

The chamois-type surface of Insular vellum has a share in making Hiberno-Saxon book decoration an art *sui generis*. The Insular scribes never had the slightest hesitation in switching from script to ornament, or even in using ornament purely for its own sake. The "carpet page" is not an Insular invention, since we know it also from Oriental manuscripts, but the zest with which it is used to increase the splendor of the manuscript in some of the Gospels presupposes an innate predilection for this type of "free" decoration. It was not limited to carpet pages only. In the Book of Kells almost every page appears "veiled in ornaments as if in clouds of incense," to quote the simile of Peter Meyer, to whom we owe a particularly penetrating analysis of the Hiberno-Saxon style of book decoration as basically distinct from Classical art.

However coherent in themselves, the ornaments could not do without a fixed framework to rivet them, as it were, to the page. For this purpose the Hiberno-Saxon artists introduced yellow fillets whose brightness made for a clearly legible structure, divided largely into geometric compartments of different size and form. As in the Durham fragment, these fillets were generally outlined, with the aid of a ruler if straight or of a compass if rounded. Thanks to its geometric regularity this controlling framework strikes the eye immediately. By contrast, the ornamental fillings are variegated and complex, a throng of particles in flux, at first sight difficult to disentangle. However, on closer inspection they too follow an orderly scheme—carefully worked out with compass and ruler. Traces of such auxiliary constructions have been discovered on the backs of some of the carpet pages in the Book of Lindisfarne. Calculated down to their smallest details, they are sometimes as complex as any mathematical group theorem.

More important than the static layout, however, is the general impression of restless movement evoked by the flowing contours of the design. More than any other style of decoration, with the possible exception of the fully developed Moslem arabesque, Hiberno-Saxon art aims at kinetic effects. In other words, there is a time element involved, which in its lilting quality suggests an affinity to music. Parallels between the different arts can only be drawn up to a point. However, an instructive approach to the principles governing the use of ornament in

our manuscripts may be found by inquiring into their "instrumentation."

Just as in an orchestra, there are three main classes of instruments—string, wind, and percussion—so here we can distinguish three main classes of ornament. These are the interlace, curvilinear, and rectilinear patterns. And just as in an orchestra there are different types of string, wind and percussion instruments, so each of the three main classes of ornament is divisible into various fixed types of pattern. Within rectilinear ornament there are the check, step, and key patterns and the diagonal fret. Curvilinear decoration comprises circles, spirals, whirls, and trumpet patterns. As to the various types of interlace, they are defined either by the dimensions of their "strings," or by the fact that they are either single, double, or triple.

Usually, animal ornament is cited as a fourth constituent—something similar to introducing the human voice into an orchestral composition. Yet it can equally well be classed as a particular—a very particular—form of interlace, the animals being interwoven to form continuous chains or laces. To start with, we find the animals themselves more or less deprived of their zoological identity, their bodies replaced by ribbons and their limbs and jaws drawn out like strings, as in the Germanic animal ornament of Style II which is at the origin of the Hiberno-Saxon variant (Figure V). A characteristic feature of these animals is that their heads and limbs may be so far apart that it is some time before one discovers how they connect. This gives them a labyrinthine quality, to the delight and despair of the spectator trying to disentangle them. To the extent that the unidentifiable quadrupeds live on in the manuscripts, they tend to be more or less treated as real reptiles.

However, the new development appears with the Book of Lindisfarne. The artist provides his quadrupeds, still band-like, with dog's heads and realistically drawn hindquarters; at the same time he introduces a new species, a bird which, to judge by its hooked bill, tarsus, and sharp claws, can only be a bird of prey, most likely a falcon. In other words, the two animals essential to the favorite pastimes of the Anglo-Saxon nobility, hunting and hawking, seem to be hinted at here. Whether this change in the vocabulary of Hiberno-Saxon ornament first occurred in secular art it is difficult to say, given the rarity of comparable non-religious objects. It may well have been an innovation of the great Lindisfarne bishop-artist.

Finally, in the Book of Kells, not only animals are included in the interlace, but also human figures, behaving like contortionists. They introduce an element of drôlerie which again reinforces the secular note inherent in all these ornaments, and which Romanesque art was to readopt with enthusiasm—with or without the approval of its ecclesiastical patrons.

The "music" produced by all these different types of pattern is very different from the tonality of Classical decorative art. Classical ornament has a design that can be grasped immediately. By contrast, Hiberno-Saxon ornament is elusive, labyrinthine in its conglomeration of undulating and swirling forms. It is no matter of chance that the key and fret patterns are directly based on the maze. The same is true of the extremely fine, almost microscopic lines of the spiral ornaments, all the more admirable in that they cannot have been drawn with the aid of a magnifying glass, a much later invention.

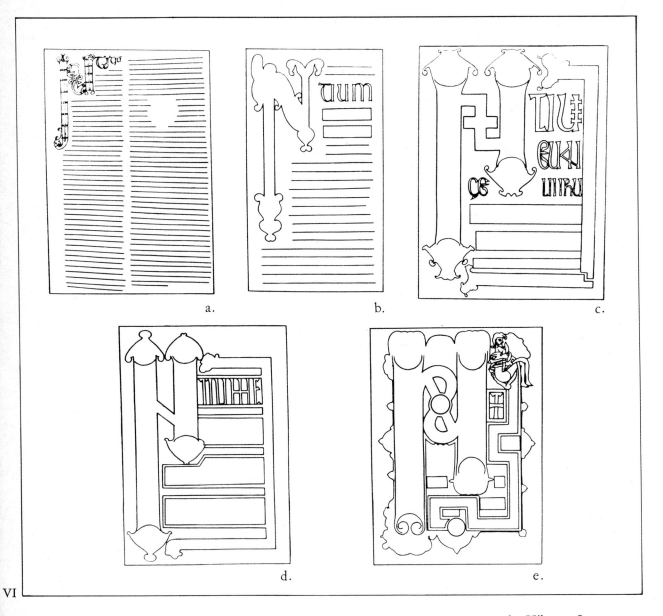

a. b. c.

d. e.

VI

Whether densely packed or forming a more open mesh, Hiberno-Saxon ornament tends to cover the ground even to the extent of suppressing it altogether or, if it remains visible, splitting it into disjointed fragments. The continuity which in Classical art is an essential attribute of the ground is here instead inherent in the patterns covering it. It is true that a similar tendency begins to be felt in Late Antique art, as Alois Riegl first pointed out, but it was the Insular book illuminators who carried it to its extremes.

Another characteristic of Hiberno-Saxon ornament is its inherent power of expansion. This is particularly evident in the scrollwork, where one curve gives birth to another in a sort of self-generating process. As a legacy of Celtic La Tène art, the system is already at work in the initials of the *Cathach of Saint Columba* (Figure II). However, only when filling the ground in a dense mass, often in obvious imitation of the enamelled escutcheons of the Celtic hanging bowls, does

it fully exert its possibilities for expansion. A similar tendency prevails with the interlace. Never at rest, it has an elasticity for expansion or contraction so that, like liquid in a container, it is able to adapt itself to the passages it must fill, if necessary changing shape from one design to the next. When used in connection with the initials, the scrollwork and the interlace actually tend to overflow, as in the famous Incarnation initial of the Book of Kells (Plate 44).

Connected with the ability of the ornament to expand is the ambition of the artists to increase in size the principal initials—from the proportionally still modest *INI* monogram of the Durham fragment to the mighty full-page compositions of the later manuscripts (Figure VI). Following this *non plus ultra,* there is an intentional regression in the size of the initials in the Canterbury manuscripts. This is most evident in the *Codex Aureus* of Stockholm, where under Classical influence the initial is reduced so that the display letters following it may fill the page in even rows, as in monumental inscriptions (Plate 38).

The complexity of the ornamental compositions presupposes an extraordinary perseverance on the part of the artist, who may well have spent days on a single page. The amount of work invested in the great *Chi* initial of the Book of Kells surpasses anything comparable in the history of book illumination. Trying not only to the patience but equally to the eyesight of a draughtsman, the work of decorating a manuscript parallels the austere self-discipline which characterized the ascetic practices of the Irish anchorites. It was another way to attain communion with God.

This raises the difficult question as to whether certain ornaments may have had a more than decorative value. It is quite possible that magical connotations from the pagan past could have been preserved when they were adapted to Christian use. In some instances, a symbolic meaning has been thought to be concealed within a design which, at first glance, would seem to be purely ornamental. For some specific motifs very ingenious interpretations have been put forward by scholars deeply read in Patristic literature but they mostly make one wonder whether the ingenuity is not that of the modern interpreter rather than of the Hiberno-Saxon artist.

One unmistakable symbol, however, does take a prominent position in the decoration of the Gospel Books, and that is the Cross. Insular stone sculpture consists, as everyone knows, almost exclusively of crosses, and it would indeed be surprising if this principal symbol of Christianity were not to appear in the manuscript as well. An Irish legend makes Adamnán of Iona perform a miracle from a great distance in favor of another abbot, exclaiming: "Wonder not that the sign of the Cross by the power of the Gospel traverses quicker than a wink of the eye all the elements up to heaven." In saying so, he is reported to have raised in his hand a Gospel Book, the cover of which, like that of the Lindau Gospels in the Morgan Library, might have featured as its decoration a large cross.

Within the Gospel Books the Cross is usually placed in the center of a carpet page. The earliest example of this appears at the beginning of the Book of Durrow. The central panel displays a double-armed cross embedded in interlace, the whole being set within a broad frame. The cross itself consists of eight squares, each with a central square and four cross-like projections—a motif repeated in the corners of the field in a lower key. An unexpected light is thrown on this composition by a document that could not be more remote, both in time and geographical location: a sixteenth-century Persian copy of the Gospel harmony of Tatian

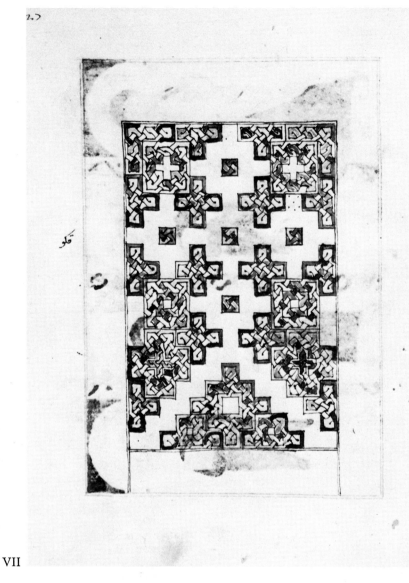

VII

called the *Diatessaron*. Like the Book of Durrow it opens with a carpet page, and although the *Diatessaron* differs in that the framing zone is left empty and the cross stands on a base, there is agreement in so many specific respects that the two pages must have a common archetype (Figure VII).

To make assurance doubly sure, one more frontispiece miniature in the *Diatessaron* codex serves to explain another characteristic feature of Hiberno-Saxon book illustration, namely the representation of the Evangelist symbols as full-length beings without wings or halos (Figure VIII, *a*). The closest parallels in this case are the symbols in the Gospels of Saint Willibrord (Figure VIII, *b*); not only do the types recur, but even such details as the positon of the hands in the image of Man and the attitude of the leaping Lion are common to both. The fact that to the earliest exponents of Hiberno-Saxon art the semi-illusionistic forms of the *Diatessaron* model were quite unfamiliar explains why the artist of the Book of Durrow

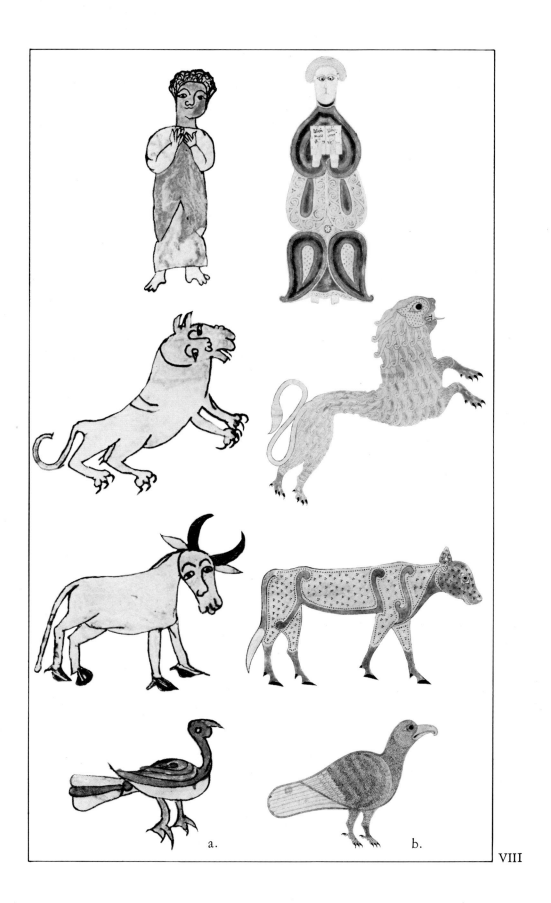

a. b.

22

IX a. b.

was not yet prepared to copy it as closely as the younger painter of the Echternach Gospels. Instead, in his drawing of the Lion and the Calf, he followed the more heraldic animal design which he knew from the sign script of the Picts (Figure IX).

We shall never establish for certain how a copy of Tatian's *Diatessaron* reached the remotest northern parts of the Christian world. The most likely explanation seems to be that Arculf, the pilgrim from the Near East, had it with him in his baggage. The sudden adoption of both the carpet page and full-length Evangelist symbols in the Book of Durrow, which really set the course for Insular book illustration, coincides with his visit to Iona.

In its early stages the religiosity of the Irish monks found artistic expression only through ornament and a few abstract symbols. It did not yet occur to the artists to illustrate the sacred texts by representations, realistic or otherwise, of Christ and the Evangelists as human beings. When they finally started to grapple

X

with the human figure after coming into contact with such representations in early Christian art, they arrived at shapes which have rightly been considered the very antipodes of classical ideals of beauty. Ornamentally stylized, sometimes almost beyond recognition, the figures represent "a sublimation of human countenance, as though it were the supernatural aspect of man's form, its mystery and its religious background, that the artist sought to portray." These words, used by T. D. Kendrick to characterize a pagan Celtic mask, apply *a fortiori* to the images in the Christian manuscripts. Whether the theme is the symbol of Man, a portrait of the Evangelist, or a portrait of Christ himself, we are faced with strange creatures in curiously frozen postures, often more like terrifying idols than venerable saints. The emphasis is on the huge eyes staring at us below arched eyebrows. By this fixed gaze, as Wilhelm Koehler has pointed out, the holy personages enter into hypnotic contact with the spectator. There is little attempt at action even where it would be called for by the subject, as in the Arrest of Christ in the Book of Kells (Plate 47). What motion there is has been concentrated in the drapery folds, which, as ornaments on the surface, assume a life of their own.

A central problem in Late Antique art was the rendering of Classical drapery in its relation to the body. Unable or unwilling to confront this challenge, the artist of the symbol of Man in the Book of Durrow evaded it by simply fusing body and drapery into a single bell-like block, lacking all indication of folds and imprisoning the arms (Plate 4). Only with the corresponding figure in the Gospels of Saint Willibrord did a younger painter make a first attempt to render drapery by translating the looping folds of the mantle in his model into a system of three pairs of still purely ornamental curves (Plate 9).

The next important step toward a real assimilation of Late Antique drapery was taken in the Durham Crucifixion (Plate 14). Here, for the first time, the colobium of Christ is rendered as a more or less homogeneous mass of softly hanging folds, which in the upper parts of the figure give the impression of a fabric draped around a body. It is to this stage in the development of Hiberno-Saxon art that the portrait of Saint Mark in the Gospels of Saint Chad belongs (Plate 24).

However, the most advanced acceptance of the Classical conception of the human figure is to be found in the Evangelists of the Lindisfarne Gospels (Plates 17, 21). We can assess this precisely by placing the portrait of Saint Matthew beside the Ezra miniature in the *Codex Amiatinus*, since both are versions of the same Early Christian model (Figure X). The Lindisfarne Evangelist is no longer covered by an artificial conglomeration of folds as in the earlier miniatures, but a real piece of cloth enwraps a seated human body. And yet the figure is no double of the faithful but rather weak copy of the Cassiodorian model in the Amiatinus Bible. A new mode of expression asserts itself in the way the mantle is stiffened by a skeleton of fish-bone-like contours and folds. At the same time, the Evangelist's head has gained a powerful new plasticity, quite different from the flattened faces of the earlier Insular miniatures and the meek countenance of the Ezra figure.

It is not probable that Eadfrith, the artist of the Lindisfarne Gospels, arrived at this new style all by himself. He must have had a fresh source, similar in style to a group of almost contemporary Byzantine ivories which once decorated an episcopal throne believed to have been that of Saint Mark of Alexandria (Figure XI). Whereas the Ezra miniature presupposes a Cassiodorian original brought to

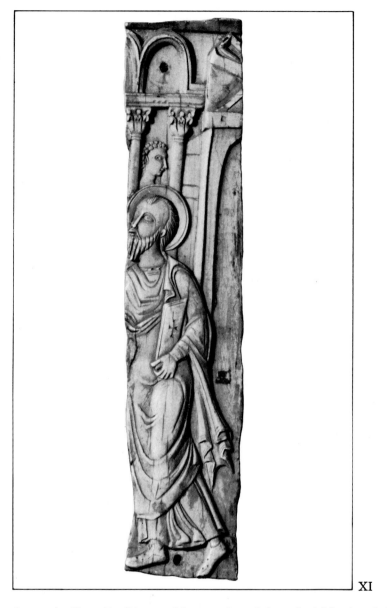

XI

Jarrow by Benedict Biscop, this second model reached Northumbria most probably through Theodore of Tarsus, the new primate of the Anglo-Saxon church sent to England by Pope Vitallian who, like Theodore, was an Easterner by origin.

Eadfrith's achievement apparently made a great impression on the other Hiberno-Saxon artists, but none of them was inclined to follow him on a road which ultimately could only lead to a complete abjuration of their native traditions. A compromise had to be worked out, and this we find most clearly reflected in the miniatures of the Book of Kells. It meant a partial restoration of the flatness and the patterning function of all forms, with a simultaneous return to an elaborate framework with gorgeous ornamental fillings.

So powerful was this partial reversion to the old tradition that even in the Canterbury miniatures of the second quarter of the eighth century there is an echo of it. The ornamental splendor of their frames is Celtic in its exuberance, and

partly so in its vocabulary. On the other hand, these pages mark further progress in the development of Insular painting toward the conquest of a three-dimensional plasticity, almost programmatically formulated in the bulging capitals of the arcade frames of the Evangelists in the Stockholm Gospels (Plates 36-37). Enthroned against a background of quasi-atmospheric shades of blue which deepen as they ascend, the figures seem to dwell in open space. However, this new insistence upon spatial values, far from diminishing the radiant power of their appearance, makes them even more convincing than their predecessors as staunch representatives of a faith that could move mountains. In that respect the old fervor of the first Hiberno-Saxon illuminators continues to assert its creative force.

Looking back at the development of Hiberno-Saxon book illumination during the seventh and eighth centuries, it seems evident that the center of gravity gradually shifted, first toward the east and then toward the south—from Ireland to Scotland and Northumbria, and from there to Kent. It was a move away from the restricted material conditions of Ireland to the more wealthy patronage of the Anglo-Saxon kings. However, Insular art would scarcely have attained its high degree of originality had it not been given its first specifically Celtic imprint on Irish soil. On the other hand, it would not have reached its high level of complexity and perfection had it remained within the confines of Ireland alone. Not only did the Anglo-Saxons bring new ornamental motifs to its vocabulary, but they also had a specific genius for order and clarity, and this they combined with a fresh inventiveness which the Irish seemingly did not possess to the same degree.

The crucial years were the last decades of the seventh century, when the Books of Durrow, Echternach and Lindisfarne were executed. They fall within the lifetime of King Aldfrith of Northumbria, who, significantly, had an Irish mother and was educated in Iona. At that time, Lindisfarne and Iona must have been the two poles between which an electric arc of unusual luminous intensity sprang to life. Modern research has tended to put the main emphasis on the Northumbrian component in this development, but the Iona of Adamnán should not be overlooked as an equally prolific center. It seems to have held a position within the history of Hiberno-Saxon book illumination not unlike that of Reichenau—another island abbey—within Ottonian art.

We would see more clearly had not both Lindisfarne and Iona in turn been completely destroyed by the Vikings. But whereas at least a part of the Lindisfarne library manuscripts—and especially its greatest achievement, the book written in honor of Saint Cuthbert—has been preserved, only a later product, the Book of Kells, has survived from Iona, if that is indeed where it was made.

In any case, the final word should not rest either with Ireland or Northumbria, but with both, one no less essential than the other for the creation of an art which, standing at the beginning, supremely vindicates the right of the Middle Ages to be called a new epoch in the history of Western art.

Adamnán. *Life of Columba.* ed. A. O. & H. O. Anderson. London 1961.

————. *De locis sanctis.* ed. D. Meehan (Scriptores latini Hiberniae, 3). Dublin, 1958.

Beda Venerabilis. *Historia ecclesiastica gentis Anglorum.* ed. B. Colgrave & R. Mynors. Oxford 1969.

L. Bieler. Ireland, *Harbinger of the Middle Ages.* London 1963.

T. J. Brown. "Northumbria and the Book of Kells," *Anglo-Saxon England.* I. 1972, 219–246.

R. L. S. Bruce-Mitford. "The Art of the Codex Amiatinus," *Journal of the Archaeological Association.* Ser. 3. XXXIII. 1969, 1–23.

N. Chadwick. *The Age of the Saints in the Celtic Church.* Oxford 1961.

A. W. Clapham. "Notes on the Origins of Hiberno-Saxon Art," *Antiquity.* VIII. 1934, 43–57.

Evangelia Quattuor Codex Cennanensis. ed. E. H. Alton et al. Olten-Lausanne 1950–51.

Evangelia Quattuor Codex Durmachensis. ed. A. A. Luce et al. Olten-Lausanne 1960.

Evangelia Quattuor Codex Lindisfarnensis. ed. T. D. Kendrick et al. Olten-Lausanne 1956–60.

A. M. Friend, Jr. "The Canon Tables of the Book of Kells," *Medieval Studies in Memory of A. Kingsley Porter.* Cambridge, Mass. 1939, II. 611–66.

I. Henderson. *The Picts.* London 1967.

Fr. Henry. *Irish Art in the Early Christian Period.* London 1965.

————. *Irish Art during the Viking Invasions.* London 1967.

————. "Les Débuts de la Miniature Irlandaise," *Gazette des Beaux-Arts.* Ser. 6. XXXVII. 1950, 5–34.

————. "The Book of Lindisfarne," *Antiquity.* XXXVII. 1963, 100–110.

W. Horn & E. Born. "On the Selective Use of Sacred Numbers," *Viator.* VI. 1975, 351–390.

J. Bröndsted. *Early English Ornament.* Copenhagen-London 1924.

K. Hughes. *Early Christian Ireland: Introduction to the Sources.* London 1972.

T. D. Kendrick. *Anglo-Saxon Art to A.D. 900.* London 1938.

J. F. Kenney. *The Sources for the Early History of Ireland.* New York 1920.

W. Koehler. *Buchmalerei des frühen Mittelalters. Fragmente und Entwürfe.* Munich 1972.

E. A. Lowe. *Codices latini antiquiores.* I–XI. Suppl. Oxford 1934–71.

Fr. Masai. *Essai sur les origines de la miniature dite irlandaise.* Brussels 1947.

P. McGurk. *Latin Gospel Books from A.D. 400 to 800.* Brussels 1961.

————. "Two Notes on the Book of Kells," *Scriptorium.* IX. 1965, 105–08.

C. Nordenfalk. "Eastern Style Elements in the Book of Lindisfarne," *Acta archaeologica.* XIII. 1942, 157–69.

————. "Before the Book of Durrow," *Acta archaeologica.* XVIII. 1947, 141–74.

————. "A Note on the Stockholm Codex Aureus," *Nordisk tidskrift för bok- och biblioteksväsen.* XXXVIII. 1951, 1–11.

————. "The Apostolic Canon Tables," *Gazette des Beaux-Arts.* Ser. 6. LXII. 1963, 17–34.

————. "An Illustrated Diatessaron," *Art Bulletin.* L. 1968, 119–40.

————. "The Persian Diatessaron Once More," *Art Bulletin.* LV. 1973, 534–46.

————. "Another Look at the Book of Kells," *Festschrift für Wolfgang Braunfels.* (In press.)

M. Schapiro. "The Miniatures of the Florence Diatessaron," *Art Bulletin.* LV. 1973, 494–531.

M. Werner. "The Miniature of the Madonna in the Book of Kells," *Art Bulletin.* LIV. 1972, 1–22, 129–39.

E. H. Zimmermann. *Vorkarolingische Miniaturen.* Berlin 1916.

LIST OF COLOR PLATES & BLACK-AND-WHITE FIGURES

ADDITIONAL BLACK-AND-WHITE FIGURES

Figure I
Dublin, Trinity College Library, 55 *Title Decoration* fol. 149v

Figure II
Dublin, Royal Irish Academy, s.n.
a) *Initial* fol. 48
b) *Initial* fol. 6
c) *Initial* fol. 12v

Figure III
Scheme of Interlaced Borders

Figure IV
Durham Cathedral Library, A. II. 10, *Initial to Saint Mark,* fol. 2

Figure V
Germanic Animal Ornament. a) Book of Durrow, b) Sutton Hoo Purse-Lid, c) Crundale Down Sword Pommel (after Bruce-Mitford)

Figure VI
Development of Initial Page to Saint Mark in Hiberno-Saxon Gospel Books: a) Durham, b) Durrow, c) Lindisfarne, d) Saint Chad, e) Kells

Figure VII
Florence, Biblioteca Medicea Laurenziana, The Persian Diatessaron, orient. 81 *Cross-Carpet Page* fol. 127

Figure VIII
a) Florence, Biblioteca Medicea Laurenziana, The Persian Diatessaron orient. 81 *Evangelist Symbols,* fol. 128v, b) Paris, Bibliothèque Nationale, The Gospels of *Saint Willibrord,* lat. 9389, *Evangelist Symbols,* fols. 18v, 75v, 115v, 176v

Figure IX
Pictish Animal Design. a) Burghead, Moray, b) Dores, Inverness-Shire (after Henderson)

Figure X
Florence, Biblioteca Medicea Laurenziana, amiat. 1 *Ezra restoring the Bible,* fol. Vr

Figure XI
Milan, Castel Sforzesco *Saint Mark*

COLOR PLATES
AND COMMENTARIES

PLATE 1

THE DURHAM GOSPEL FRAGMENT I
fol. 3v *Colophon to Saint Matthew*

Seven leaves, now dispersed in three codices (A.II.10, C.III.13 and C.III.20), are all that remain of this important book, the earliest painted Hiberno-Saxon manuscript. Written in two columns, it was possibly a New Testament like the later Book of Armagh.

Two of the pages preserved in A.II.10 are decorated. On fol. 2 the Gospel of Saint Mark starts with a monogram initial *INI-* in the left column (Figure IV). Originally preceding it, the present fol. 3v has in the left column the end of the Gospel according to Saint Matthew, with the last eleven lines in a calligraphic minuscule hand. (For a special treatment of the same last verses in another Durham Gospel fragment, A.II.17, fol. 38, see text for Plate 14.)

In the right column, an elaborate framework, consisting of three loops piled one above the other, forms a wing, as it were, to the text column. In the openings the colophon is inscribed in light red ink, now much faded, which was later partly duplicated in black. The uppermost loop contains the *Explicit* to Matthew and the *Incipit* to Mark, and the other two are filled by the Greek text of the Lord's Prayer in Latin characters, as it appears in the Book of Armagh and in the earliest copy of Adamnán's Life of Columba, signed by his successor Dorbbene.

The broad plaited ribbons in the spandrels resemble those on two early Irish steles at Fahan Mura and Carndonagh. The pelta ornaments in the outer corners form a debased Celtic scroll and trumpet motif, related to the initials in the Cathach of Saint Columba (Figure II). The construction of the closely packed interlace borders is described above (see Figure III).

discendit decaelo et accidens reuoluit
lapidem et sedebat supereum Erat
autem aspectus eius sicut fulgor et ue
stimentum eius candida uel ud nix praeti
more autem eius exterritisunt costo
des et facti sunt uelud mortui Respon
dens autem angelus dixit mulieribus
Holite timere uos scio enim quod ihm
xpm qui crucifixus est quaeritis non
est hic surrexit enim sicut dixit uenite
et uidete locum ubi positus erat dns
et cito euntes dicite discipulis eius quia
surrexit amortuis et ecce praecidit
uos ingalileam ibi eum uidebitis ecce
dixi uobis exierunt cito demonumen
to cum timore et gaudio magno currentes
ter nuntiare discipulis eius et ecce ihs
currunt illis dicens hauete ille autem ac
cesserunt et tenuerunt pedes eius et
adorauerunt eum Tunc ait illis ihs ho
lite timere ite nuntiate fratribus
meis ut eant ingalileam ibi me uidebunt
quae cum abissent ecce quidam decor
todibus uenerunt incuitatem adhunt
tauerunt principibus sacerdotum om
nia quae facta fuerant et congregati
cum senioribus consilio accepto pecunia
copiosam dederunt militibus dicentes
dicite quia discipuli eius nocte uenerunt
et furati sunt eum nobis dormientibus
et sihoc auditum fuerit apraeside nos sua
debimus et securos uos faciemus at illi
accepta pecunia fecerunt sicut erant
instructi et deuulgatum est uerbum istud
apud iudaeos usq: inhodiernum diem∴
VHdecim autem discipuli eius abierunt in
galileam in montem ubi constituerat
illis ihs et uidentes eum adorauerunt quid
am autem dubitauerunt et accedens ihs locutus
est eis dicens data est mihi omnis potestas ince
lo et interra euntes ergo nunc docete omnes
et baptizantes eas innomine patris et filii et
sps sci docentes eos obseruare omnia quae
cumque mandaui uobis et ecce ego uobiscum
sum omnibus diebus usque adconsumma
tionem saeculi ∴⁓⁓⁓⁓ ⁓⁓⁓⁓⁓ ⁓⁓⁓⁓

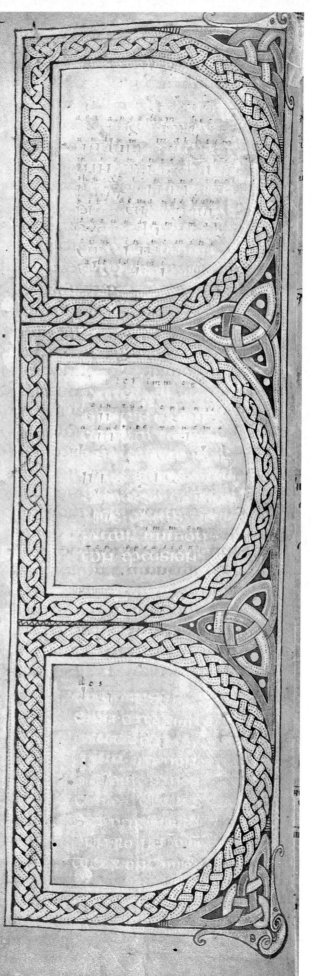

PLATE 2

THE BOOK OF DURROW
fol. 1v *Carpet Page with Double-Armed Cross*

Written about 680 A.D., the Book of Durrow is the earliest of the fully decorated
Gospel Books, containing Canon Tables (not yet architectonically framed), carpet
pages and full-page pictures of the Evangelist symbols. It is also the first to have
a repertory of both Celtic and Germanic ornaments, not yet integrated and therefore
in the earliest stage of development. The text is essentially the Vulgate version,
with a certain number of Old Latin readings, possibly reflecting the import of good
Italian texts to Northumbria by Benedict Biscop. The prefectary matter is unques-
tionably Irish.

A colophon at the end mentioning Saint Columba as having completed the book
in the space of twelve days is copied from an older exemplar.

The manuscript opens with a carpet page featuring a so-called Patriarchal cross
in an oblong central panel set into a broad frame, wider above and below to adapt
the composition to the oblong page. In general layout and in the construction of
the central panel the folio resembles the carpet page at the beginning of the Persian
Diatessaron codex in Florence (Figure VII). Obviously both depend upon a com-
mon Early Christian archetype.

Beside the brownish-black appearing as a dark foil to the interlace, the dominat-
ing colors are three: red lead, yellow orpiment, and, less frequent, green verdigris—
a copper acetate which in several places has eaten right through the vellum.

3

PLATE 3

THE BOOK OF DURROW
fol. 3v *Carpet Page with Scroll Work*

Having introduced the carpet page, the artist of the Book of Durrow went on to compose other similar decorations, repeating interlace motifs in the border but substituting Celtic scrollwork for the cross.

Six medallions, imitating the enamelled escutcheons of the hanging bowls, fill the central panel: two large ones in the center and four somewhat smaller above and below. The remaining areas are covered by trumpet patterns, endowed with a strong upward or downward pull. The medallions, which in turn contain small ring spirals, produce a maximum of rapid gyration.

The border of plaitwork originally continued around all four sides. In design, it is based upon a sophisticated point-counterpoint of six intricately interlaced ribbons, forming clusters of four knots within undulating crossing bands.

It is not certain where this carpet folio, now on a single sheet, originally belonged. Most probably it faced the beginning of Saint Matthew which now, unlike the other Gospels, has no carpet page of its own.

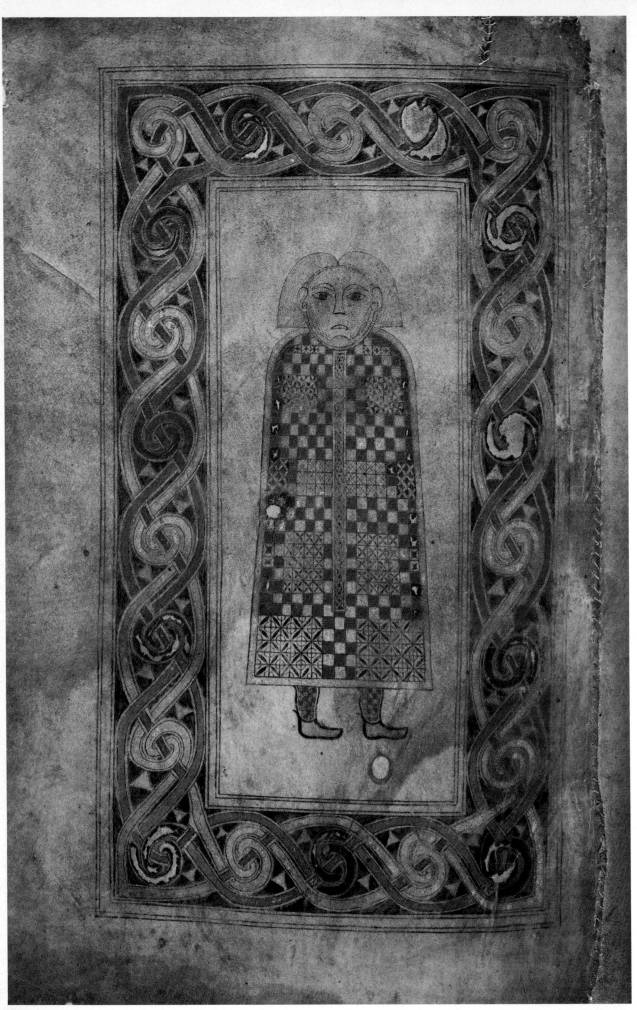

PLATE 4

THE BOOK OF DURROW
fol. 21v *The Man, Symbol of Matthew*

Facing the Gospel of Saint Matthew is his symbol, the Man, a doll-like figure
enclosed in a heavy ornamental frame. His flat body is covered by a checkered
pattern of varied *millefiori* inlay ornament, completely concealing the arms. The
broad frontal head is attached without a neck, and at the bottom two parallel feet
emerge, turned in profile and marching right.

 Although stylized, the figure does not entirely lack realistic features. The slanting
contour of the body suggests a monk's cowl, and the hair, hanging straight from the
forehead behind the ears, reminds us of the Irish tonsure as we know it from other
representations of Celtic saints.

 Slightly narrower on the inside, the double-line mouldings of the frame have
been left without color, the three pigments, yellow, red and green, being reserved
for the broad ribbons of plaitwork, which are reinforced by an edgeband. The
slanting direction of the knots creates the impression of rolling waves against the
dark space. In its powerful kinetic effect the border almost overwhelms the image
in the center.

PLATE 5

THE BOOK OF DURROW
fol. 86 *The Beginning of the Gospel of Saint Mark*

The two first letters of the opening word *Initium* form a monogram by uniting the *I* and the first vertical stroke of the *N* in a double stem which descends to the first full line of text. Landing as they do at different levels, the initial and the decorative capitals obey the "diminuendo" law of Hiberno-Saxon book decoration.

The vertical stems of the monogram initial have yellow edgebands and a filling of rhythmically changing interlace threads, white on black leaving colored areas at both ends. By contrast, their terminals burst into colorful spiral and trumpet patterns, and the slanting bar of the *N* consists entirely of curvilinear forms in rotating movement.

The color scheme is based exclusively on red and yellow, black and white, except for a patch of green added with great refinement in the pelta ornament on top of the double stem. To the left of it, the curling scrollwork overflows in a cluster of whirls and trumpets. In the open space below the *N*, *S*-lines and dots in red act as space-fillers connecting the initial with the text block.

Clearly, the whole page is treated as a coherent decorative unit.

Incipit euangelium
secundum marcum

INITIUM
euange
liihuxpi
filidi sicutsc
riptumineseia
pnofeta · Ecce mittoan
gelum meum antefaciem
tuam quipraeparabituia
Uox clamantis indeser
to parate uiam dni rec
tas facite semitas eius
Fuit iohannis indeserto
babtizans &praedicans
babtismum paenitentiae
Innemisionem peccatoru
&egrediebatur ad illum omnes regi
iudeae regio &hierusolimitae uni
uersi &babtizabanturabillo Inior
dane flumine confitentes peccatasua
&erat iohannis uestitus pilis cam

78

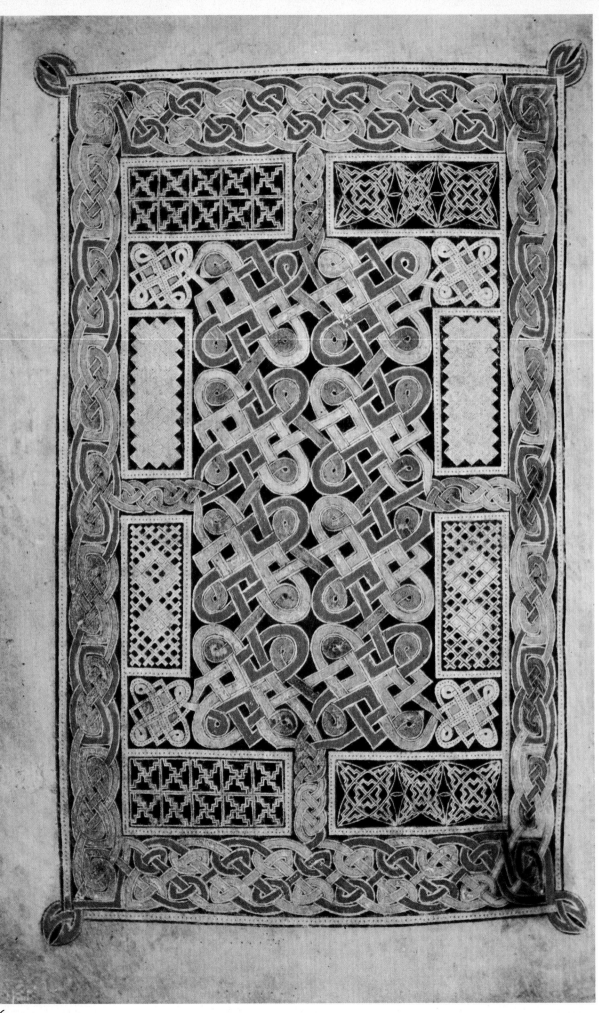

6

PLATE 6

THE BOOK OF DURROW
fol. 125v *Carpet Page with Inlaid Panels*

Facing the Gospel of Saint Luke, the center of this carpet page is filled by broad
four-strand interlacing, forming a set of eight quadrilobes with rounded and angu-
lar turnings. Reduced to a finer type of ribbon, it traces similar figures in all four
corners. On the vertical and horizontal axes of the page, the colored ribbons slip
through openings into the more compact plaitwork of the border that—starting
with the interlaced horns in the corners—generates in turn the outer edgeband.

Inserted in this stream of multi-colored interlace, eight rectangular panels with
steps and grid patterns in white on black introduce a set of contrasting static
elements. On the vertical sides they are connected in pairs by a fillet, which helps
to define the inner limit of the border space.

Here the verdigris pigment has proved less dangerous for the vellum than in the
preceding pages, so that this carpet decoration is among the best preserved in the
whole manuscript.

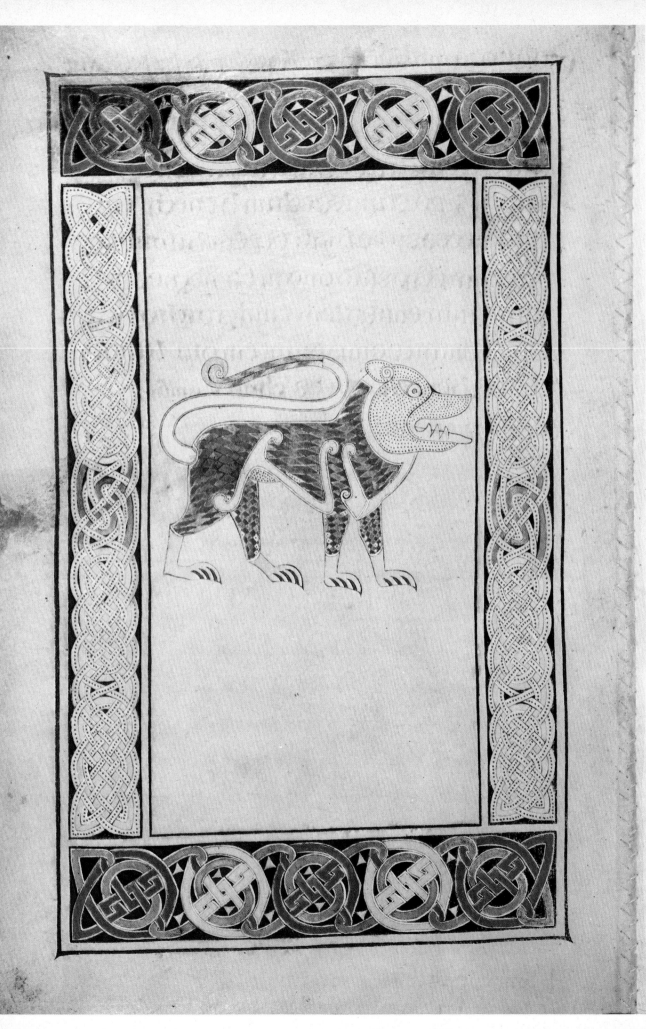

PLATE 7

THE BOOK OF DURROW
fol. 191v *The Lion, Symbol of John*

In the Book of Durrow, Saint John's symbol is not the usual Eagle but, following the pre-Jerome order, the Lion.

The beast is drawn in profile walking towards the right, with raised tail curving over its back. The fur is rendered as lozenges in alternating colors, like the pattern of a Harlequin costume. In the voluted design of the hip and shoulder joints the Lion resembles the incised quadrupeds on the Pictish symbol stones (Figure IX). The head is shaven, and the beast's open jaws probably suggest that it is roaring.

With its marching gait the Lion fills less than a third of the open field within the frame, which by contrast has the oblong upright format of the page. The border consists of four panels. Those at the top and bottom are filled with broad, interlaced ribbons in red, yellow, and green, repeating the colors in the body and legs of the animal, while the side panels, with a more open and finer type of ribbon, echo the Lion's dotted head and the curled tip of its tail.

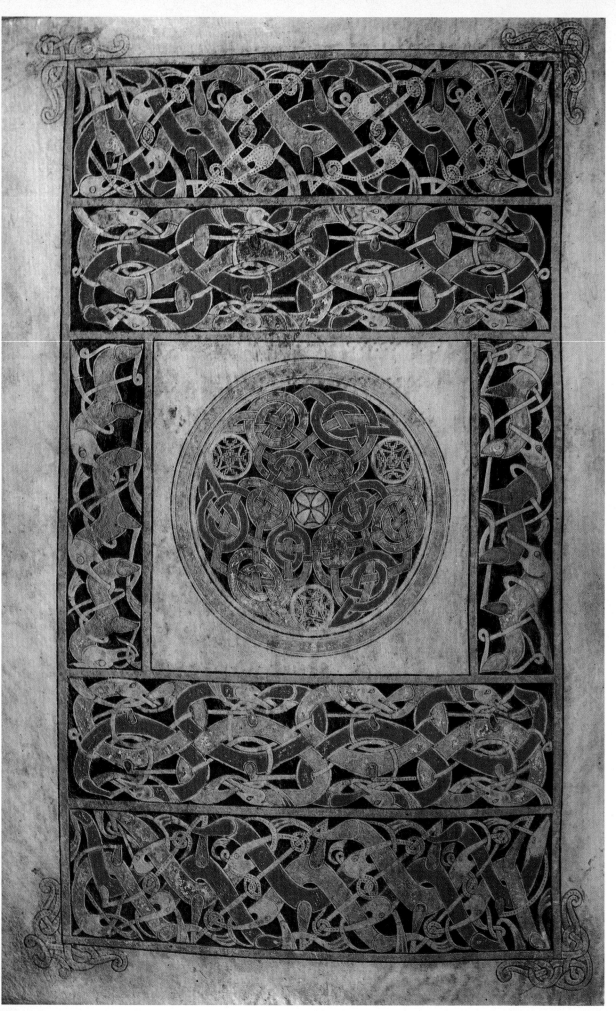

PLATE 8

THE BOOK OF DURROW
fol. 192v *Carpet Page with Animal Interlace*

As a central motif the carpet page facing the beginning of Saint John features a circular medallion filled with plait work of multicolored ribbons, forming two rows of tight knots. Inserted in the center and at even distances along the periphery are four small discs in black and white. Whereas the central disc with its cross may well have a Christian connotation, the suggestion that the other three allude to the Trinity is less certain as Christ is already suggested by the cross. Similar medallions, with discs alternating with band ornaments, occur on a pagan stele from Valstena on the island of Gotland in Sweden, and in the enamelled escutcheons on the large hanging bowl from Sutton Hoo, where there can be no question of Christian symbolism.

The central medallion is set freely in the opening of a framework consisting of oblong panels, repeated at top and bottom to conform with the format of the page. According to their size and interlace animal fillings the panels correspond in pairs: 1 and 6, 2 and 5, and 3 and 4, if numbered from top to bottom. Panels 3 and 4 have a procession of quadrupeds biting each other, similar to those of Anglo-Saxon workmanship on a sword pommel from Crundale Down (Figure V). The double rows of interlocking animals in the other panels are more reptilelike in body, those in 2 and 5 forming crossing C-curves like the beasts on the ivory purse from Sutton Hoo (Figure V), while those in 1 and 6 interlace in jumping movements.

PLATE 9

THE GOSPELS OF SAINT WILLIBRORD
fol. 18v *The Man, Symbol of Matthew*

Later than the Book of Durrow (c. 680 A.D.), but before the Book of Lindisfarne (c.700 A.D.), the Gospels of Saint Willibrord was no doubt presented to him on his journey to convert the heathen Frisians in 690 A.D. On historical grounds it was most probably ordered by his mentor Egbert, a pious Anglo-Saxon living in exile among the Irish.

Possibly owing to the pressures of time, the scribe has written the main text *per cola et commata* in a speedy minuscule script, reserving the majuscule for the prefatory matter.

Lacking carpet pages, the Willibrord Gospels follows the Book of Durrow in having full-page pictures of the Evangelist symbols, represented as full-length figures without wings and haloes—the types known to us from the Persian Diatessaron (Figure VIII).

A colophon on fol. 222v, copied from the exemplar, mentions that the text was corrected in 558 A.D. after a manuscript said to have belonged to Saint Jerome. Nevertheless, the Gospels of Saint Willibrord is far from being a pure Vulgate version. Instead it features a mixed text, typical for a scriptorium still preserving Celtic textual traditions. The chapter lists agree with those in the Books of Durrow and Kells.

A slightly later Gospel Book of the same school, not included in this survey, has

been preserved in fragments, divided between Cambridge (Corpus Christi College Library 197) and London (British Library, Royal 7 C.XII and Cotton Otho C V).

As in the Book of Durrow, Saint Matthew's symbol is a frontal full-length figure. The title *IMAGO HOMINIS* is written at the level of his head in large display script. His hands are raised to the chest in a symmetrical posture similar to that of the image of Man in the Persian Diatessaron (Figure VIII). The classical garment of the archetype, common to both, has been schematized into three pairs of drop-like curved borders, with only an intimation of the underlying tunic above the feet. An open book placed between the fingers carries the introductory words of the Gospel, *Liber generationis Ihesu Christi*, written in the same pointed minuscule as the colophon. The slightly squinting eyes are lowered as if reading. The hair has a tonsure, not as in the Book of Durrow, according to the Irish, but in the Roman fashion. Behind the figure a high-backed throne has been interpolated and this, like the Gospel Book stuck behind the raised hands which is foreign to this set of symbols, suggests the identification of the symbol with the Evangelist himself.

Conformable to the size of the page, a wide frame with fillings of broad plaited ribbons sends arms inward which hold the figure and its throne as in a vise—a cross turned, as it were, inward. The contrast between the curvilinear forms of the figure and the rectilinear framework creates a composition of high tension.

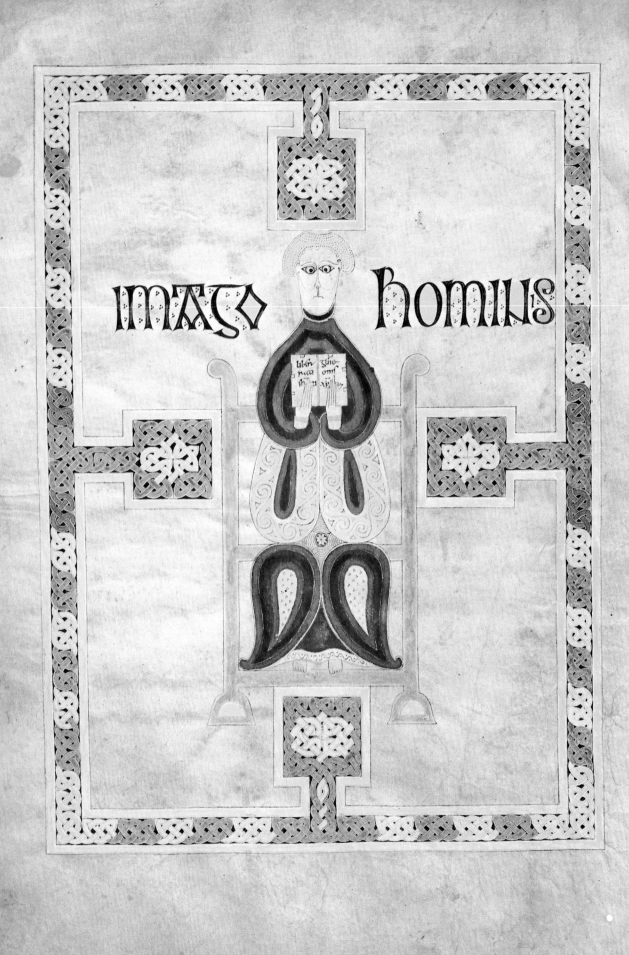

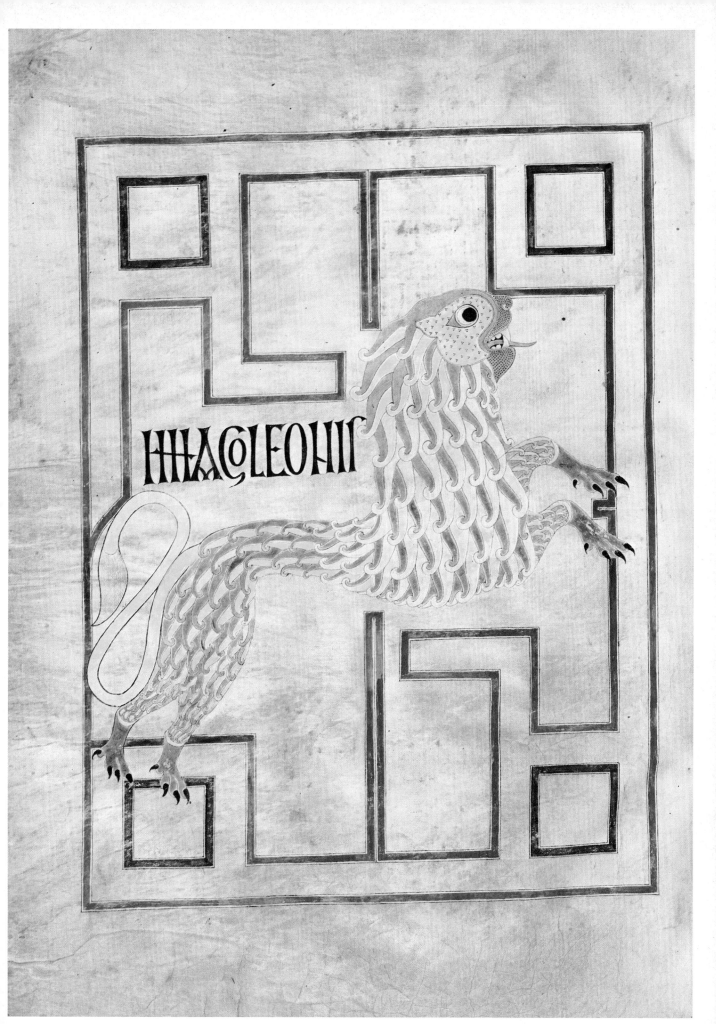

10

PLATE 10

THE GOSPELS OF SAINT WILLIBRORD
fol. 75v *The Lion, Symbol of Mark*

Unlike the cramped image of Man, the Lion of Saint Mark conveys an impression of freedom and power. Not walking calmly like the lion in the Book of Durrow, but rising up in a prancing leap, the beast is given a forward impetus by the inscription *IMAGO LEONIS* behind its neck.

This image, too, derives in posture from the Diatessaron model, as we see it nervelessly reflected in the Persian version (Figure VIII). The splendid heraldic quality of the Lion, however, is new—linking it with representations of animals in Pictish art.

The beast is caught in a rectilinear labyrinthine framework, consisting of two diagonally corresponding partitions. They create a sounding board for the rampant Lion, whose curvilinear forms contrast sharply with the straight lines of the frame. Since the feet of the Lion cut into the borders, it is probable that they were intentionally left without a filling.

This is perhaps the greatest masterpiece of all designs in Hiberno-Saxon books.

PLATE 11 53

THE GOSPELS OF SAINT WILLIBRORD
fol. 176v *The Eagle, Symbol of John*

Like most animals in Hiberno-Saxon art, the Eagle, here as usual the symbol of Saint
John, is shown in strict profile. With lowered wings and squatting posture the bird
is far from resembling the imperial eagle of Roman art. Indeed, were it not for the
powerful hooked bill and sharp claws, it could scarcely be taken for a bird of prey.
Nevertheless, it possesses a noble heraldic quality, chiefly due to its strictly con-
toured silhouette.

An essential part of the design of the bird betrays the use of a compass. By
contrast, the framework emphasizes straight lines, drawn with a ruler. With its
symmetrical pattern slightly modified to accord with the form of the bird, it holds
the Eagle firmly enclosed between its three-pronged structure, as in a flat cage. The
result is again a strong tension between the rectilinear and the curvilinear forms.

PLATE 12

THE GOSPELS OF SAINT WILLIBRORD
fol. 177 *The Beginning of the Gospel of Saint John*

In comparison with the *IN* monogram in the Book of Durrow (Plate 5) this page
marks a considerable progress in the refinement and conjoint action of all forms.
The descending stems of the *I* and the *N* are drawn apart and the uprights of the
N united by an angled bond of the same width and treatment. As a result, the inter-
lace filling can now flow uninterrupted throughout the whole monogram.

A powerful black contour outlining the yellow fillets has the effect of graphically
uniting the initial and the black fancy letters beside and below it. At the terminals
this contour becomes a much finer line, ending in a new type of spiral with squeezed
sides jutting out like a flag. Here the asymmetrical cluster of scrollwork, situated
at the upper left corner in the Durrow initial, has found a more organic place, filling
a curve at the bottom of the double descenders and developing out of the dagger-
like tip.

A conscious attempt is made to coordinate the symbol and the initial by repeating
the yellow and mauve colors of the bird in the interlace fillings of the monogram;
likewise the deep red of the framework in the symbol page is echoed in the rubric,
the line fillers, and within the spirals of the monogram.

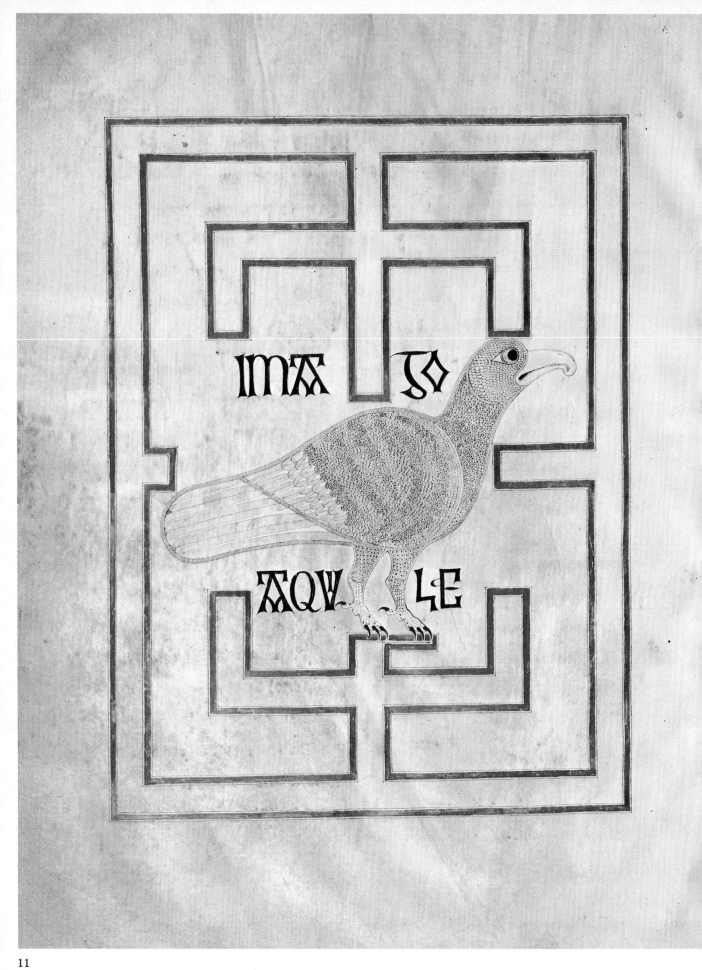

IMA GO AQU LE

11

IN PRINCIPIO ERATVRBM

& uenbum
enat ap
ud dm
& ds enat
uenbum
hoc enat Inprinci
pio apud dm
Omnia phypsum
facta sunt
& sine ipso factum
est nihil
Quod factum est
Inipso uita enat

Incipit euangelium secundum
Iohannen
& uita enat lux
hominum
& lux Intenebris lucet
& tenebrae eum non
conpraehenderunt
Fuit homo missus
adeo nes
Cui nomen enat Iohan
hic uenit Intestimonium
ut testimonium pen hi
bret delumine
Ut omnes credebrnt
phillum
Non enat ille lux
Sed uttestimonium
phibret delumine
Enat lux uena quae
Inluminat omnem
hominem
Ueniennem Inhunc mundu
Inmundo enat
& mundus phypsum
factus est

12

PLATE 13

THE DURHAM GOSPEL FRAGMENT II
fol. 1 *The Beginning of the Gospel of Saint John*

Apart from the earliest example of a richly decorated Gospel text (Plate 1), the Cathedral Library of Durham owns a more substantial fragment of a second fairly large Gospel Book, datable toward the end of the seventh century. Unfortunately, the full page decorations are lost with the exception of two, a Crucifixion and the opening initial for the Gospel of Saint John.

The artist of this initial has clearly been influenced by the corresponding one in the Gospels of Saint Willibrord (Plate 12). The coupled descenders, the continuous flow of the interlace filling, the medallion in the center of the cross-member of the *N,* and the interlacing of the letters *P* and *R* are common to both. However, there are also notable differences. The interlace filling is now transformed into the thronging life of interwoven quadrupeds with birdlike heads. Contrasting with their red and white bodies, the framing fillet is no longer yellow, but green. Lacelike plaited knots replace the scrollwork at the terminals of the stems, except at the bottom of the coupled descenders where, in the resemblance to the Willibrord initial, the curved daggerlike tip again generates a cluster of whirling spirals.

Both initials have been ascribed to the same artist. Yet, despite their affinity, the contrary can equally well be argued. The perfect economy in the layout of the initial and in the design of its ornamental fillings and terminals, typical of the Willibrord master, has given way in the Durham fragment to an extravagant multitude of scintillating forms. The distance of time, at most a few years, that may separate the two manuscripts does not suffice to account for so radical a change. Two different artistic temperaments at work seems to be the more valid explanation.

PLATE 14

THE DURHAM GOSPEL FRAGMENT II
fol. 38v *The Crucifixion*

This miniature is painted on the back of a leaf which has the last four verses of Saint Matthew inscribed within a frame decorated with fine dotted interlace on the recto. This decoration, showing through the vellum, has a disturbing effect on the miniature, which has also suffered from rubbing and humidity.

Attached to the cross, which extends to the borders, the figure of Christ, clad in a tunic and a profusely plaited mantle with sleeves, occupies a zone in front of the rest of the picture and dominates the composition. His forearms only are stretched along the transverse bar of the cross, an unusual posture which finds a parallel in one of the Palestinian ampullae of Monza.

Above the transverse Christ is flanked by two birdlike seraphim, while below stand the bearers of the sponge and the lance—two dwarflike figures with slender legs appearing from beneath striped cloaks.

Christ's scalloped halo flows down to his shoulders like a wig, a misconception which the miniature shares with the Irish bronze plaque of the Crucifixion from Athlone, which generally features the same iconography.

A severe bearded figure, Christ seems unaware of the sponge held close to his mouth. All expression is concentrated in his gaze, which, like that of the seraphim, is firmly riveted on us. An inscription running right round the miniature begins in the upper right hand corner: *Auctorem mortis deieciens, uitam nostram restituens, si tamen compatiamur,* ". . . if we feel compassion"—evidently the miniature is conceived as an *imago pietatis* to encourage meditation on the sacrificial death of Christ.

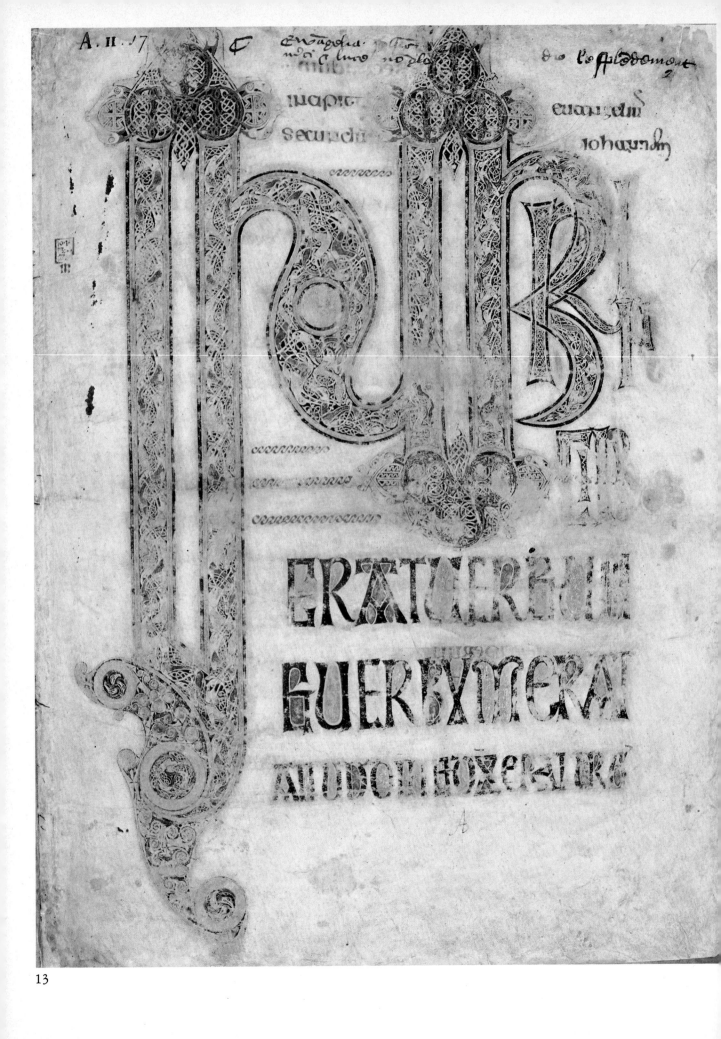

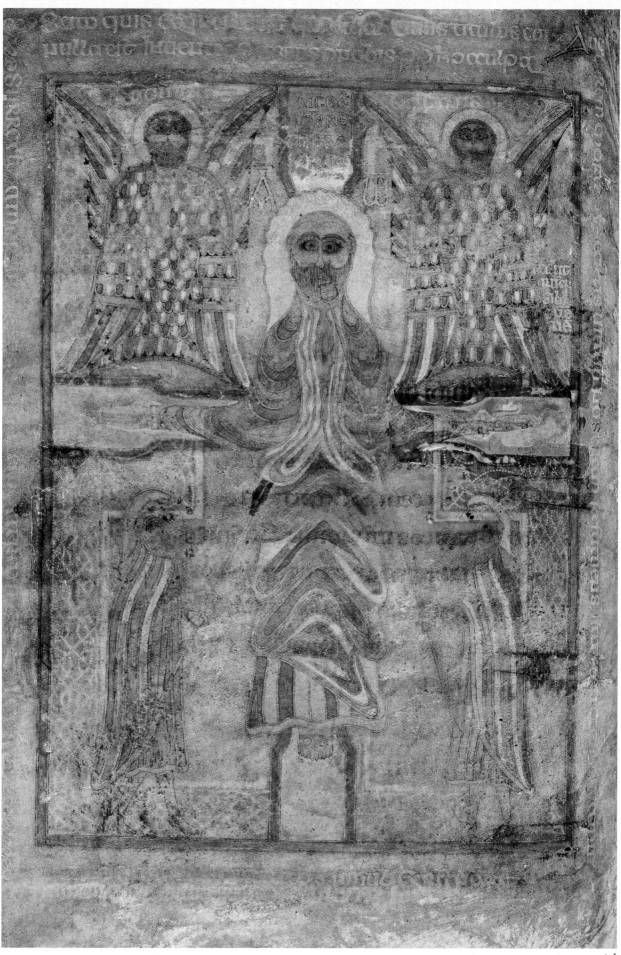

14

PLATE 15

THE BOOK OF LINDISFARNE
fol. 2v *Carpet Page with Cross*

The Book of Lindisfarne takes its name from the monastery for which and in which it was written. It remained there until 875 A.D., when the monks, taking with them the relics of Saint Cuthbert and the Gospel Book, were forced by Danish invaders to leave their holy island. During the time the book was at Chester-le-Street, Alfred, a provost of the local church, entered a word for word translation into Anglo-Saxon between the lines of the Latin text, and having finished his work, he added a colophon stating that the manuscript had been written by Eadfrith, Bishop of the Lindisfarne Church, for God and for Saint Cuthbert; that the binding was due to his successor Ethelwald; and that Billfrith the anchorite adorned it with a precious cover in gold and precious gems.

This statement is generally taken at face value, leaving the question open as to whether Eadfrith completed the book before he became a bishop in 698 A.D. or during his episcopate. In a study of the manuscript, the most thorough ever devoted to a single book, T. J. Brown and R. Bruce-Mitford reached the conclusion that the former alternative is the most probable. They were also able to show that Eadfrith was not only the scribe, but also the decorator.

The art of Eadfrith presupposes a training in the tradition of Columban book decoration as we know it from the Book of Durrow and its successors, a tradition which may, or may not, have been kept alive in Lindisfarne after Whitby. On the other hand, it is an example of the repercussions of contemporary Mediterranean art in far-away Northumbria, once the whole of England had been brought under obedience to Rome by Theodore of Tarsus. Archbishop Theodore, who arrived in 669 A.D. as papal emissary, is known to have consecrated the church of Lindisfarne at some time before his death in 690.

Like the Book of Durrow, the Lindisfarne Gospels opens with a carpet page, and again the principal motif is a cross formed by interconnected squares. Here, how-

ever, there are only six squares instead of eight, the cross having but one transverse arm. In the center of each square is a square rivet, and around it flows a diagonal step pattern.

Between the arms of the cross are four separate panels, filled with an intricate step pattern surrounded by red fillets in contrast to the blue edging of the cross. They are slightly narrower in width than the squares of the cross, in order to allow for an even distribution of the fine double-strand knotwork colored in a pattern of alternating red and yellow checks. Although the cross and the panels at first glance seem to float above the ground of interlace, they are at the same time treated as inlays—a sophisticated spatial ambivalence which no doubt is part of the game.

The exterior border has a strip of interlocking birds moving in a continuous procession counterclockwise. As an extra edging there is a red fillet developing at the four corners into interlaced finials with double dog heads, turned inwards and ending in a small rosette disc, like the one seen in Plate 12, projecting under the second stem of the N of the Gospels of Saint Willibrord.

As Walter Horn has shown, the layout of the whole design is prepared by a modular grid pattern, the basic divisions of which are multiples of the width of the framing bands.

At the top of the cross are two small unfinished areas in the coloring of the interlace fillings. They give us a glimpse of the underdrawing in brown ink and even a few faint traces of the grid used in the construction. There are no marks betraying the use of a compass, the knotwork being drawn freehand.

In several places, when adjacent to orpiment yellow, the red lead has suffered discoloration due to a chemical reaction. This is a phenomenon that can be observed more or less consistently throughout the book.

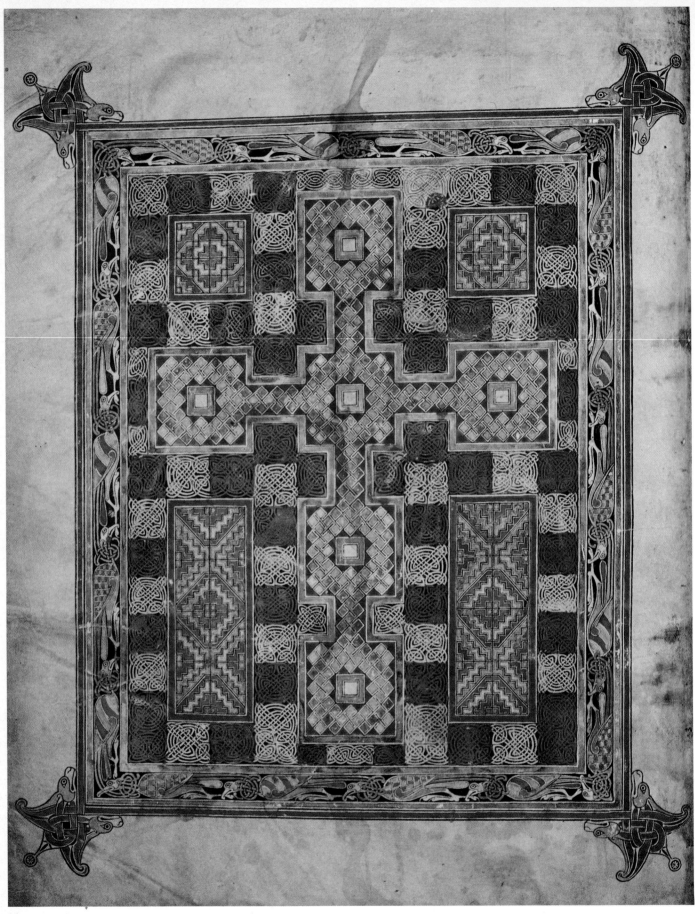

15

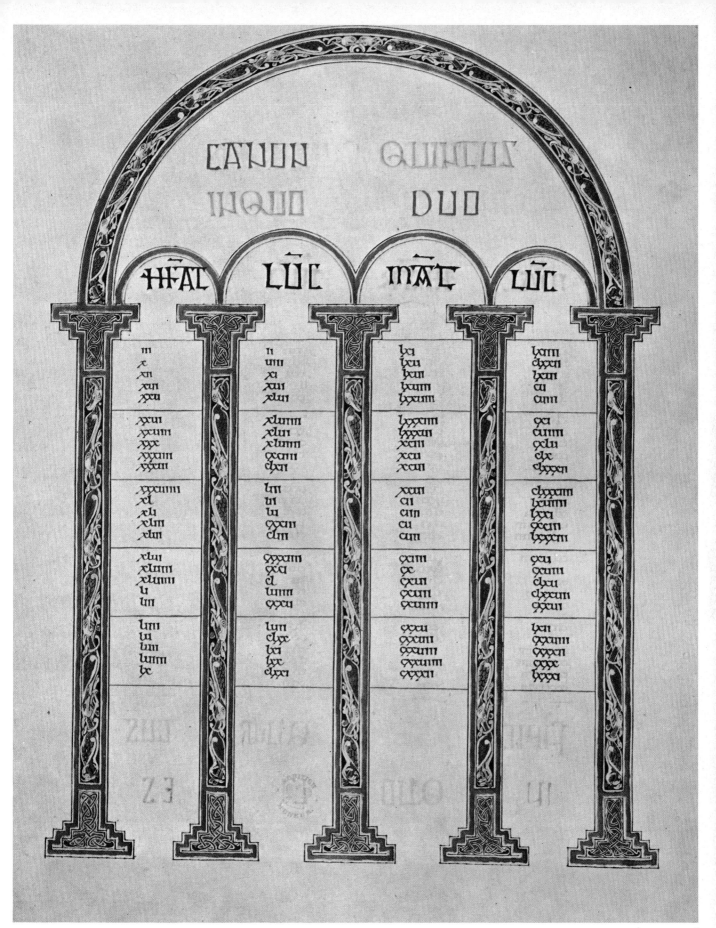

16

PLATE 16

THE BOOK OF LINDISFARNE
fol. 14v *Canon Table*

The numerical tables devised by Eusebius of Caesarea in about 330 A.D. for draw-
ing up concordances between the four Gospels, the *Canones evangeliorum,* were
from the very beginning set in painted and decorated arcades designed to frame
and support the tables. Saint Jerome added them to his Vulgate, and in both the
Book of Durrow and the Gospels of Saint Willibrord they are among the prefatory
matter, but enclosed by rectangular borders only.

The first Hiberno-Saxon Gospels to show all the Canon Tables inscribed in
painted arcades is the Book of Lindisfarne. Whereas Saint Jerome distributed them
over twelve pages, here they occupy sixteen—a new layout of which this is the
oldest surviving example.

Those facing one another are treated as pairs with regard to the ornamental fill-
ings of their slim columns and arches. On two pairs of arcades the filling consists—
as seen on the preceding plate—of bird chains, similar to the border of the first
carpet page. A procession of birds was used to fill an early Islamic arch in a painted
chamber of the desert castle at Kusejr Amra, and it occurs again, this time applied
to a Canon Table, in a twelfth century Gospel Book from the scriptorium of the
Holy Sepulchre in Jerusalem (Rome, Biblioteca Vaticana, Vat. lat. 5974 fol. 8).
Both these parallels point to an Oriental source of inspiration for this motif.

PLATE 17

THE BOOK OF LINDISFARNE
fol. 25v *Portrait of Saint Matthew*

Instead of the symbols only, the Book of Lindisfarne has full-length portraits of
the Evangelists themselves at the beginning of each Gospel. The first of them, Saint
Matthew, is shown seated on a bench, writing in a heavy open codex. His winged
symbol towers about his halo, blowing a trumpet, symbolizing his mighty voice.
The name of the Evangelist is written in angular fancy letters, preceded by the
Greek for "the holy," *O AGIOS;* above the symbol, *imago hominis* is inscribed in
ordinary majuscule.

Not identified by any inscription, a nimbed bearded man, also holding a book,
peeps out from behind a caught-back curtain. As pointed out by Bruce-Mitford, a
golden rubric at the beginning of the Gospel text identifies him with Christ. Con-
sequently the curtain probably suggests "the veil of mystery" of the Holy of Holies.

Whereas the Evangelist closely resembles Ezra in the Codex Amiatinus (Figure
X), the inclusion of Christ as a witness betrays a knowledge of the Greek two-figure
Evangelist iconography, and allows us to assume a second model, which clearly has
had an impact on the whole style of the miniature. The sharp-cut faces, the riblike
folds of the garments, the dot and circle ornament on the bench, and the symbol,
turned in profile and emerging over the head of the Evangelist, are all features
which have parallels in a group of late seventh century ivories of Eastern origin,
illustrating the life of Saint Mark as bishop of Alexandria (Figure XI).

The color harmony is based mainly on the contrast of saturated red and pale blue,
with a yellow tone added in more limited areas, a triad diagrammatically repeated
in the interlaced finials of the simple frame.

The pinkish background does not really create the impression of an airy space
between the figures. Rather they form a spatial continuum of their own, cut out
and applied to a void, with the bench touching the frame, and the footstool the
lower point of the curtain, as in an *opus interrasile*—a typically medieval formula.

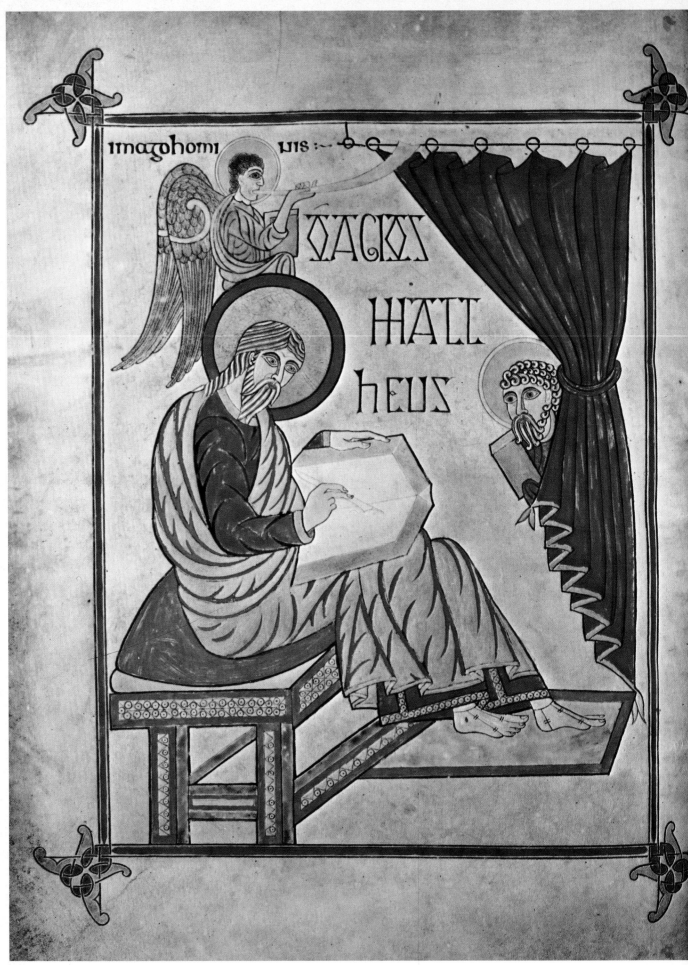

imago homi nis :~

SCS MAT heus

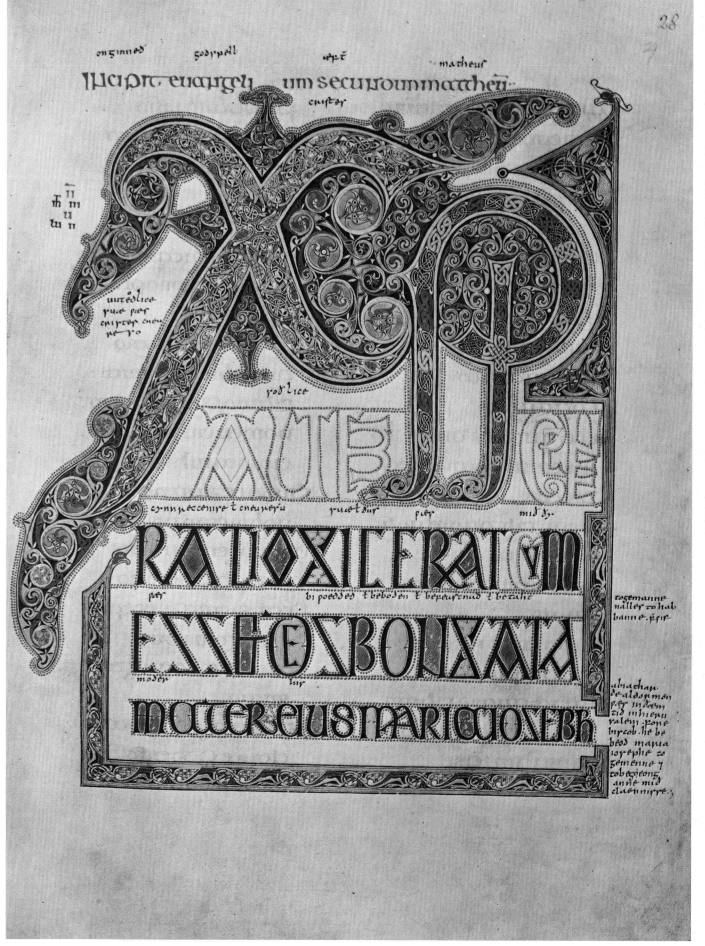

18

PLATE 18

THE BOOK OF LINDISFARNE
fol. 29 *The Incarnation Initial*

A noble lineage was highly esteemed among the Celts and Anglo-Saxons. Consequently they attached a special importance to the genealogy of Christ with which the Gospel of Saint Matthew begins. The transition from the Old Testament forefathers to Christ himself provided an occasion to glorify his Greek *nomen sacrum*, *XPI*, at the beginning of the sentence *Christi autem generatio* ("Now, as to the birth of Christ"). This took the form of a monogram initial, starting with a huge X which in the course of development assumed an increasingly elaborate form.

The Book of Lindisfarne is the first to devote an entire page to it. The three sacred letters occupy the upper half of the panel, followed below by four lines of text in display script, gradually diminishing in size as they descend. The main stroke of the X forms a rising diagonal, the upsurge of which is carried back by the descenders of the coupled letters P and I. Filling the interstices, clusters of scrollwork accompany the fanfare of the initials like a rolling of drums.

Along the lower and right sides of the panel a partial framework of intertwined birds encloses the lines of fancy letters. In the lower right hand corner where the text ends, the frame opens up, as if indicating that the sentence has its continuation on the verso.

PLATE 19

THE BOOK OF LINDISFARNE
fol. 26v *Carpet Page with Animal Interlace*

Facing the beginning of Saint Matthew is a carpet page again featuring a cross as its central motif, but this time spreading across the entire panel. Instead of squares, the cross is made up of a circular element in the center, while the arms consist of five bell-shaped protrusions, each with a circular rivet in the middle.

Within the arms of the cross and all around them different patterns of animal interlace form a tightly packed carpet—within it quadrupeds only, and around it quadrupeds and birds interlocked. Enforced by an invisible grid of linear coordinates, the animals are grouped together into an easily surveyable number of symmetric units. In spite of the intricacy of their churning forms, law and order rules the design—a *tour de force* of decorative inventiveness.

On the exterior edge of the panel a light green band is carried out in the corners in stepped contours, thereby opening up subsidiary areas for a minute interlace. Halfway along the sides, interlaced excrescences create a slight note of disharmony since they do not coincide with the transverse arms of the cross.

PLATE 20

THE BOOK OF LINDISFARNE
fol. 94v *Carpet Page with Scattered Panels*

The carpet page at the beginning of the Gospels of Saint Mark has an all-over pattern of double-strand fine interlace similar to that of the first carpet page (Plate 15). This time, however, instead of a cross, there are a number of separate panels assembled around a central medallion. Contrasting with the rectilinear patterns filling the medallion and the oblong panels along the periphery, the four triangular panels have a filling of animal interlace and the four square panels of scrollwork.

At the four corners and in the middle of all four sides, the outer band of the frame extends into excrescences of symmetrically built knots, interwoven with birds and dogs in such a way that the bodies and heads are separated from one another, the bodies being enclosed in the corner knots and the heads in the intervening protrusions.

Constructed like the other carpet pages on a carefully thought-out system of fixed modules, this carpet page, featuring the entire vocabulary of Hiberno-Saxon ornament in a harmonious alternation of motifs, stands out as one of the most accomplished creations of the great Lindisfarne artist.

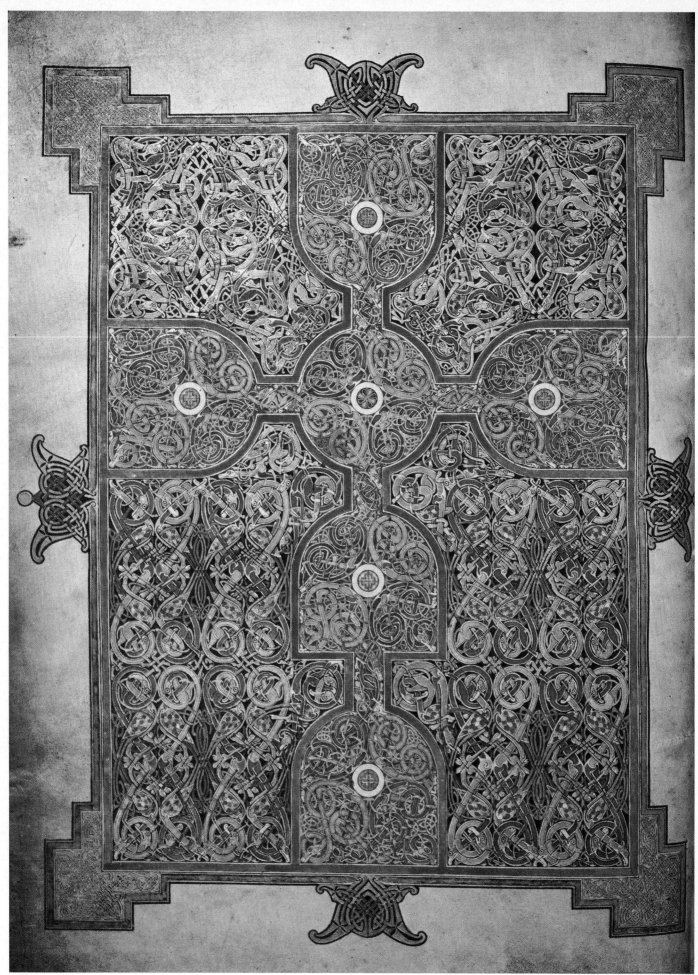

19

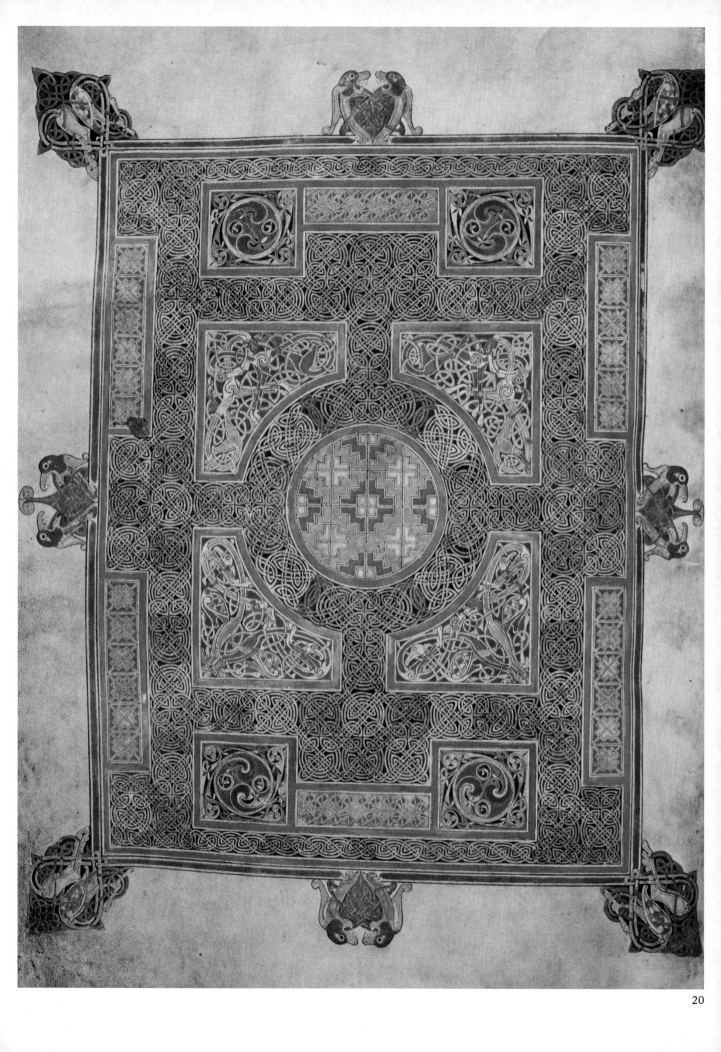

PLATE 21

THE BOOK OF LINDISFARNE
fol. 209v *Portrait of Saint John*

As in quite a number of medieval Gospel Books, the fourth Evangelist is singled
out as a personality different from the other three. Whereas the others are shown
in profile writing their Gospels, Saint John alone faces the spectator frontally with
an open scroll spread over his knees. His right hand emerges from the fold of his
mantle in a gesture which must have a special meaning, since only in his case does
it occur again in the incised portraits of the Apostles on the reliquary shrine of Saint
Cuthbert. A possible explanation is that as the Apostle of love, he is placing his
hand on his heart.

The rising diagonal of the scroll is stressed by the thumb of his right hand, and
by his symbol, the Eagle, flying upward to the right from behind the Evangelist's
halo. The holy inspiration is not something brought to the fourth Evangelist from
outside; it comes from within. Unlike the symbol of Matthew, the Eagle has no
trumpet signifying his voice.

The Evangelist is seated on an openwork bench, the carpentry of which defies
calculation since it is conceived mainly from a decorative standpoint. Its rectilinear
design forms an effective contrast to the piling up of curving folds around the body
of the figure, culminating in the red halo, now brownish in hue where the yellow
rim has affected the adjacent pigment. The strictly frontal face of the Evangelist is
clean-shaven—the pink and brown complexion painted thickly on a plaster ground
with green shadows down the sides of the nose and above the eyebrows. The fixed
gaze of his wide open eyes imperiously commands our attention.

The unique position held by Saint John among the Evangelists is also stressed by
placing his name in yellow characters on red. The artist's innate love of symmetry
has caused him to misspell the Latin word for eagle in the inscription (*ae-quil-ae*
instead of *aquilae*).

PLATE 22

THE BOOK OF LINDISFARNE
fol. 211 *The Beginning of the Gospel of Saint John*

The first three letters of the opening words *In principio* have been enlarged and
united to form the sturdy monogram that occupies the left side of the composition.
It is followed by five rows of decorative capitals, enclosed within a border in two
sections ending in small dog heads and leaving a passage open in the lower right-
hand corner, so as to let the text continue—on the next page.

Whereas the framing borders have a running filling of interlace, in the breadth
of the ribbons they are still reminiscent of the frame of the Saint Matthew symbol
in the Gospels of Saint Willibrord (Plate 9). The double uprights of the mono-
gram, the *Z*-shaped crosspiece of the *N*, and the earlike double curve of the *P* are
all divided into separate panels, charged with alternating broad animal and fine
abstract interlacing. A further articulation is introduced by three diamond-shaped
lozenges with step patterns, cutting the double stems.

Prefigured in the Willibrord Gospels, in the clumps of scrollwork accumulations
at the bottom of the initial to Saint John (Plate 12), the protrusions at the terminals
of the monogram have curvilinear patterns, split by a wedge of zoomorphic or
linear interlace—an attempt to overcome the customary segregation of the different
classes of ornament within strictly limited areas.

The decorative capitals are aligned between double rows of red dots and connect
up with the monogram by further dotted fillings in the form of an airy plaitwork.
The letter *C* in the second row has a swinging line ending in a girl's head—an early
drôlerie motif, unique in this manuscript.

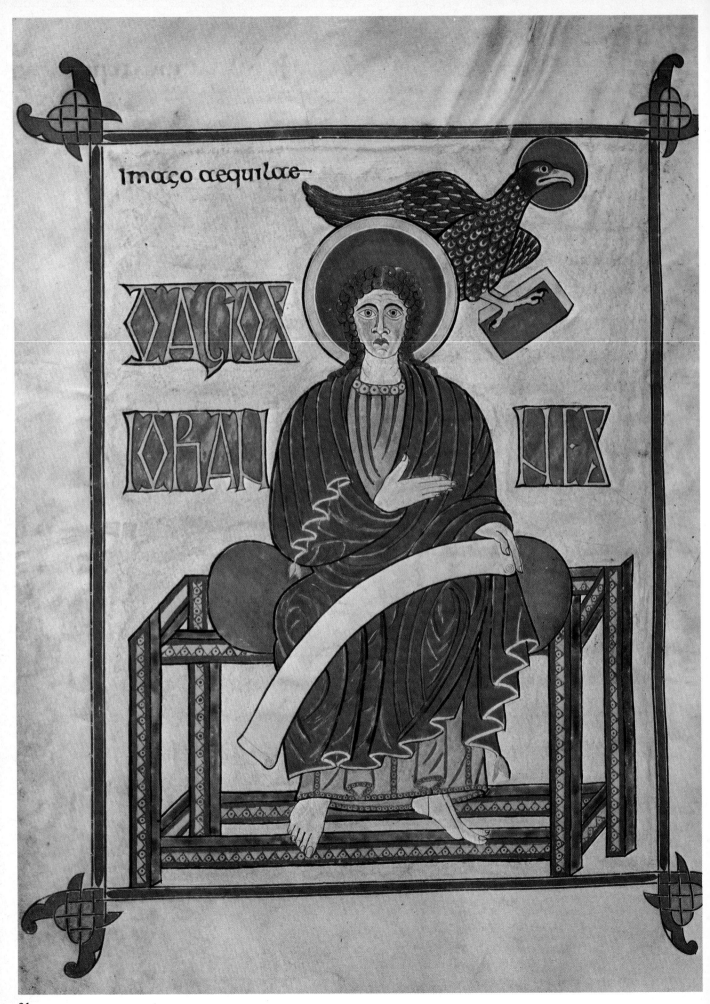

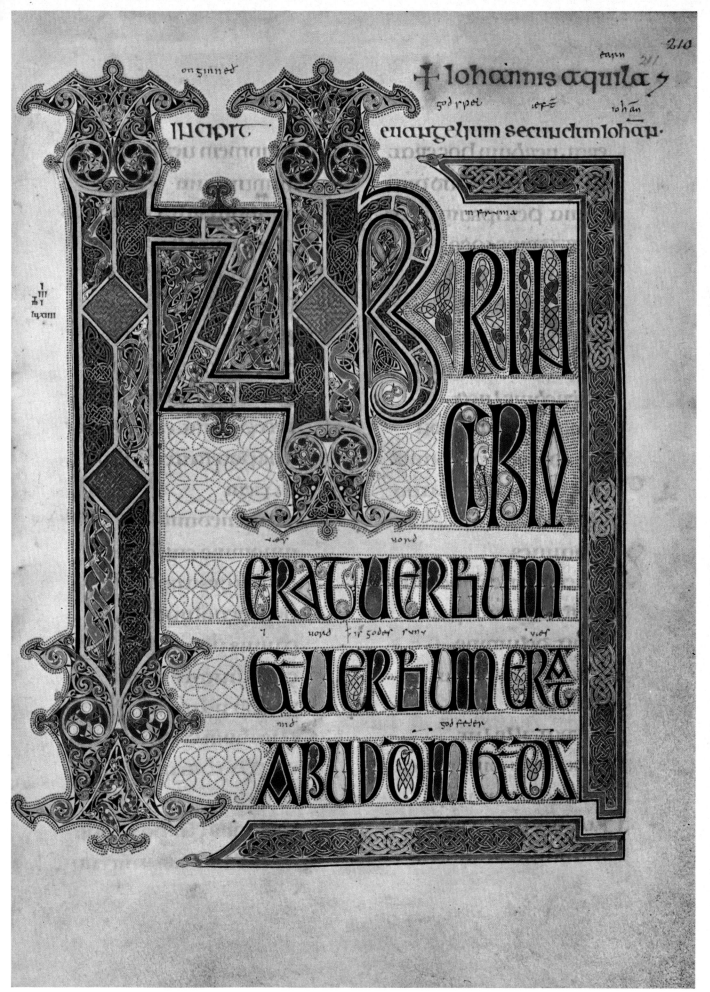

onginned

✝ Iohannis aquila ⁊

Incipit euangelium secundum Iohan·

IN PRIN
CIPIO
ERATUERBUM
 GUERBUM ERAT
ABUDOMEDT

PLATE 23

THE GOSPELS OF SAINT CHAD
p. 5 *The Incarnation Initial*

Tradition connects the book with Saint Chad, or Ceadda, who was educated at Lindisfarne and died as Bishop of Lichfield in 672 A.D.—long before this manuscript was written. Prior to Lichfield, it was in Wales, as is apparent from two older entries, one of them mentioning the acquisition of the book for the price of a horse.

Lacking the prefatory matter at the beginning, the Gospels of Saint Chad ends imperfectly with Luke 3:9. Fortunately, it has retained a complete set of decorated pages introducing the Gospel according to Saint Luke, namely a portrait of the Evangelist, a quartered page with all four symbols in separate panels, a carpet page and a full-page initial. There is reason to assume that the other Gospels were treated similarly. As in Durham A.II.17, the last page of Matthew is framed, as well as the genealogy of Christ according to the same Evangelist. It is, as usual, followed by a full-page Incarnation initial.

In designing this initial, the artist undoubtedly used as his model the corresponding composition in the Book of Lindisfarne. It conforms precisely in the filling of a large X with a zigzag succession of twisted birds, in the scrollwork at the terminals, and in the interstices of the initials, as well as in the coupling of the P with the I.

But this agreement does not exclude certain equally obvious deviations. The left diagonal of the X, for instance, is carried down here to the bottom of the page. Below it, the frame starts with the hindquarters of a quadruped and ends in the upper right-hand corner with a curled around open-mouthed head. The three lines of black, fancy letters are set between borders emanating from the frame. They end in the upper left corner in a zoomorphic projection.

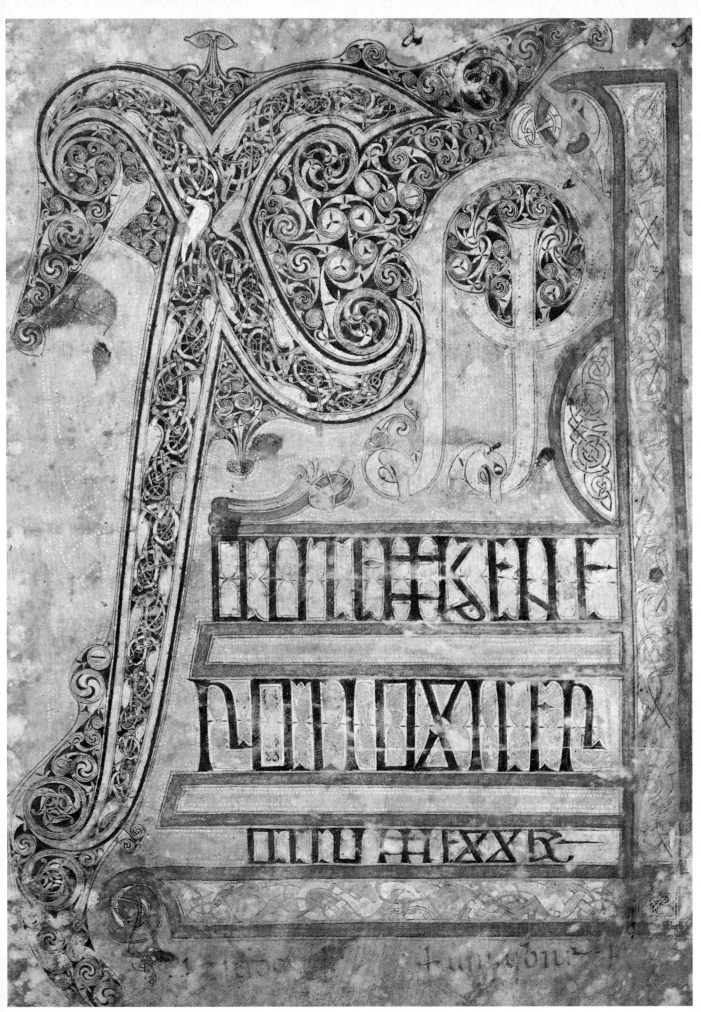

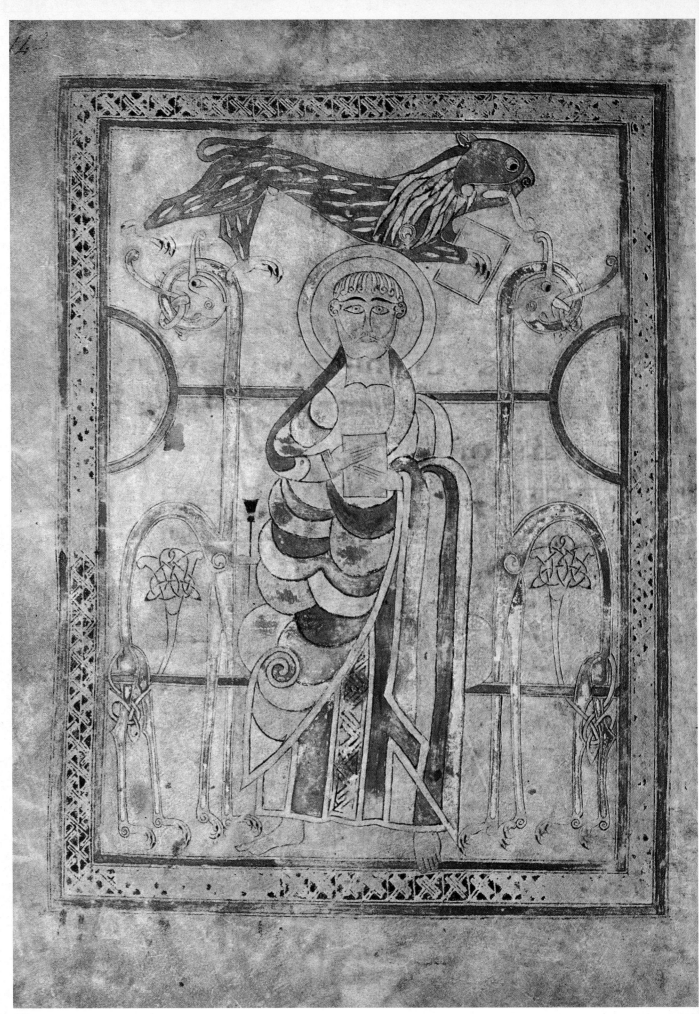

PLATE 24

THE GOSPELS OF SAINT CHAD
p. 142 *Portrait of Saint Mark*

The red fillets of the rectangular frame enclose a fret-filling in white and black.

Within, a bizarre type of throne is attached to the fillets on either side, the vertical members being animated in the form of two thin quadrupeds with elongated legs and necks, terminating in curled-up heads with open jaws, a long tongue, and two upstanding ears. The lower bar of the seat carries a cushion and to the left a short bar supports a little black inkpot on a long stick.

In front of his throne stands the Evangelist, a book held chest-high with both hands, his legs wide apart, one foot seen from above, the other turned in profile. Behind the neck and over the right arm the tubular folds of the mantle are wound in a manner which still reminds us of a classical toga. Other parts of the dress have disintegrated into ornamental patterns—the crescent-shaped flaps on the left suggestive of the treatment of the drapery in the Durham Crucifixion (Plate 14).

Over the haloed head of Saint Mark towers his symbol, the Lion, in a position similar to the Lindisfarne Evangelist portraits. The beast itself, derived from a rampant lion, is an offspring of Saint Mark's symbol in the Gospels of Saint Willibrord (Plate 10). Lacking wings and halo, the Lion has a book stuck between its paws.

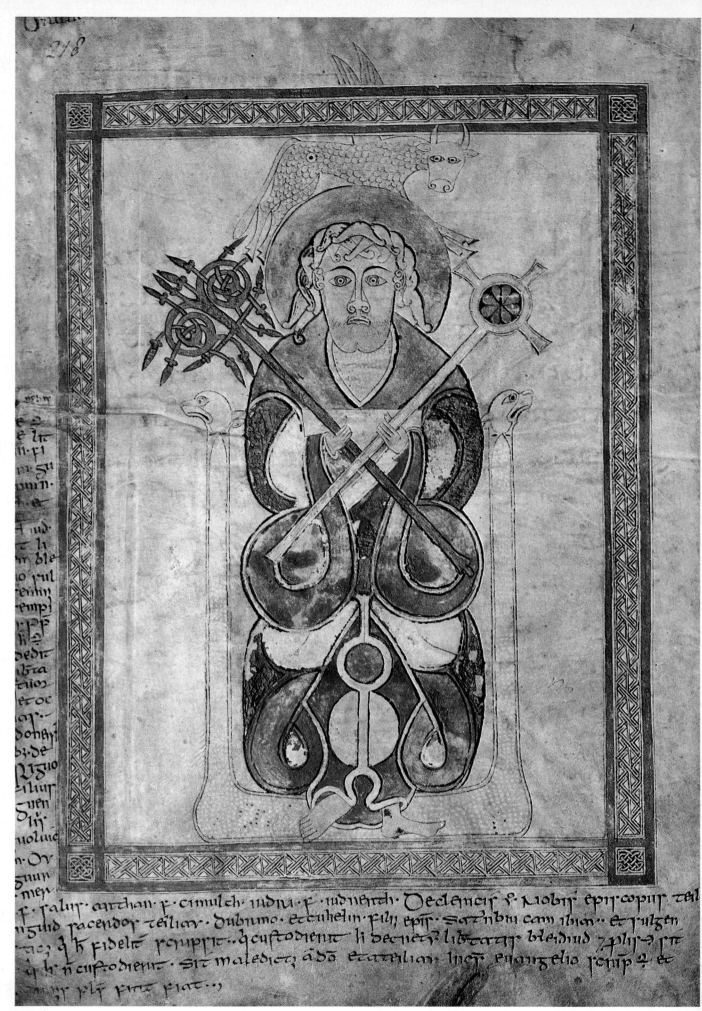

f. ralur. arcchan. f. cimulch. uidru. f. udnerch. Declencir f. riobir epir copur til
nzuid racendor teiliar. dubnuno. ecculhelin. fili epir. Sarnibtu cam ibien·· et ruben
q h fidelm rerurrit··q cuſtodient li decnech librarir bleidiud Zplir · rt
q h ncuſtodient · Sit maledict; a do ecaruilian ingr euangelio rcrup q· et
rr rlr rnr fiat·;

25

PLATE 25

THE GOSPELS OF SAINT CHAD
p. 218 *Portrait of Saint Luke*

A rectangular frame, almost identifical with that of the portrait of Saint Mark, encloses an entirely different figure. The Evangelist stands frontally in a boatlike piece of furniture, strewn with white dots and ending in two uprights with dog heads. In his stunted hands he holds two crossed ceremonial staffs, one whitish yellow ending in a cross with a pink eight-petal rosette, the other bluish green branching out in two spiral rinceaux with arrow-shaped leaves. Possibly representing two different forms of the Tree of Life, they add to the ceremonial dignity of the figure.

In contrast to the semi-illusionistic treatment of the drapery in the portrait of Saint Mark, the garment of Saint Luke has the character of an ornamentally stylized pattern. It forms a few broad loops on both sides of the central axes of the figure, in accordance with the tradition of the *Imago hominis* in Saint Willibrord's Gospels (Plate 9). Out of this rigidly schematized dress, the two feet, emerging in a classical *contrapposto* position, are something of a surprise.

Between the halo and the frame, Saint Luke's symbol, a rather small Calf, is squeezed in such a way that, together with the scepters, it forms a lozenge around its master's heavy head. The spell emanating from the Evangelist's staring eyes, repeated by those of the symbol, is compelling.

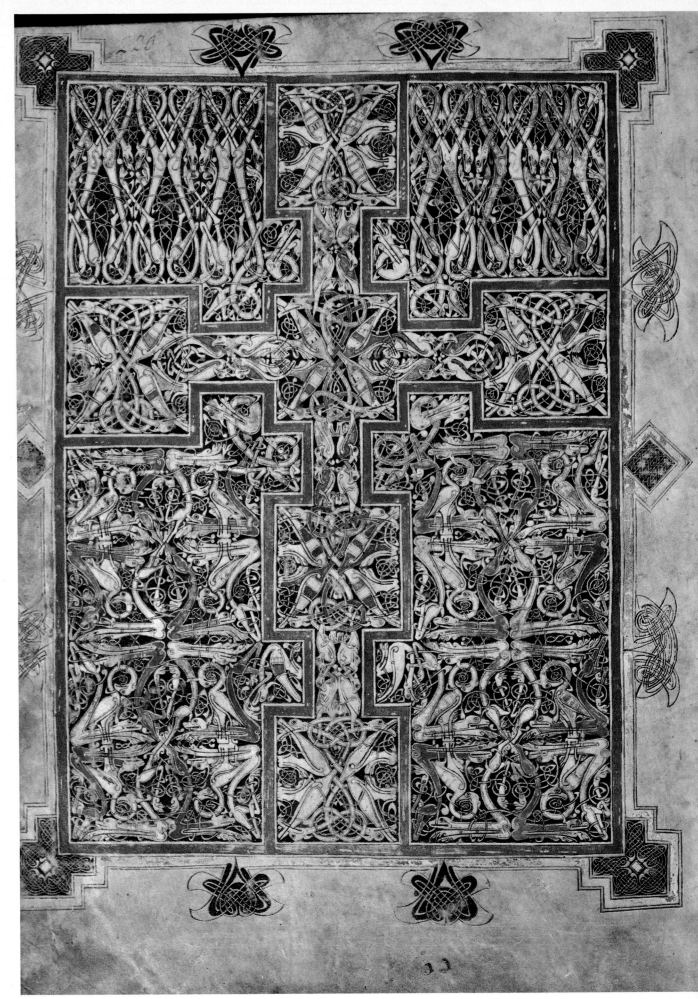

26

PLATE 26

THE GOSPELS OF SAINT CHAD
p. 220 *Carpet Page with Animal Interlace*

The only carpet page still preserved in the Gospels of Saint Chad is inspired in
design by a corresponding page at the beginning of Saint Matthew in the Book of
Lindisfarne (Plate 19).

The purple-red fillets outlining the cross turn at right angles to form six inter-
connected squares. As in Lindisfarne, they run directly into the inner band of the
border, dividing the panel outside the cross into four separate compartments. In
these surrounding areas, as well as within the cross, we find tightly packed patterns
of animal interlace—again in close resemblance to the Lindisfarne page, with the
difference that the motifs along the top and bottom are now reversed, and that the
cross has a filling of birds instead of quadrupeds. Of greater significance are the
differences in proportions and structure. The animal bodies detach themselves
more clearly from their interlaced necks and tails, the pelta-shaped quadrupeds
being confined to the four in the angles between the cross arms. Because the simpli-
fied-color scheme is common to all areas, the cross does not appear superimposed
on the space around it, as it does in the Lindisfarne page.

The white outer fillet of the frame forms excrescences at the corners as in
Lindisfarne, but those between have grown in number—hardly for the better, the
Lindisfarne artist would probably have thought.

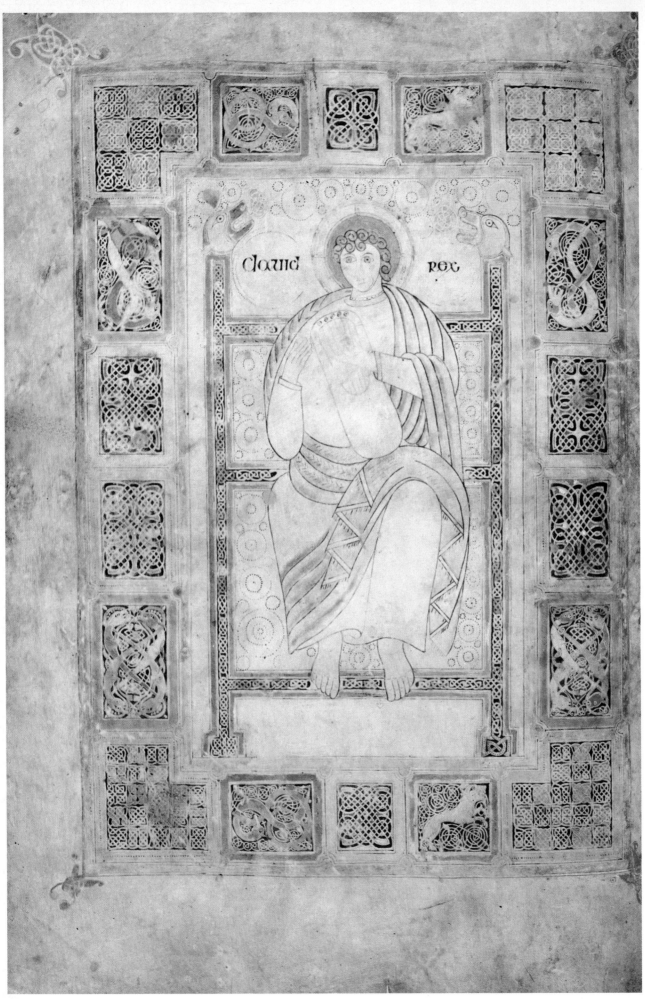

27

PLATE 27

THE DURHAM CASSIODORUS
fol. 81v *King David as Musician*

According to medieval tradition, this manuscript was written by Bede; if so, he can only have been one of six expert scribes who shared in the production. However, it may well have been executed in his lifetime.

In spite of the imposing size of the codex, the text has been drastically abbreviated, so that it is brought within the compass of a single volume instead of the usual three. It is divided into three sections that begin with Psalms 1, 51 and 101; the last two are prefaced by full-page portraits of King David. A corresponding third miniature, now lost, was most probably at the beginning of the codex.

Seated on a high-backed throne built of flat slats with sideposts ending in dog heads, the King in the first of the surviving images plays on a five-stringed, lyre-shaped harp with a rounded sounding board—a type of instrument documented in fragments from the Sutton Hoo ship burial. On his stocky body is placed a small head with reddish ringlets, surrounded by a blue halo with a broad rim. The tubular folds of the mantle presuppose the drapery style of the Lindisfarne Evangelists (Plate 21), as do the stepped edges of the cloth hanging down on either side of his left knee.

The King's name and title are set in double dotted circles, repeated in smaller rings floating like bubbles in and above the framework of the throne.

The wide border is divided up into panels with fine-strand interlace. Two on each side have red or green borders and animals as insets, including two lifelike leaping lions, enmeshed as it were in the fine plaitwork emanating from their tongues and tails.

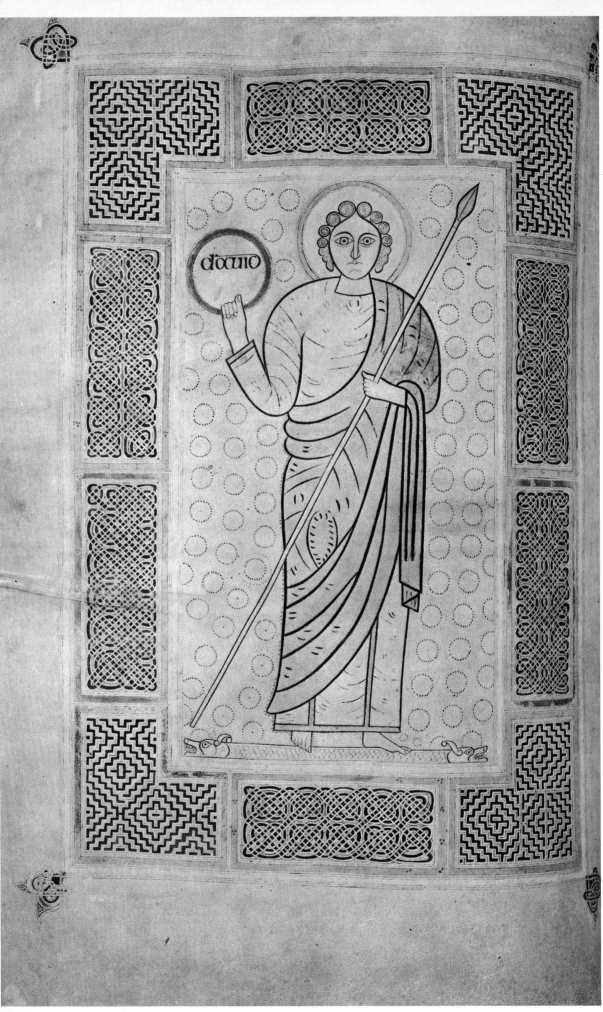

dixiio

28

PLATE 28

THE DURHAM CASSIODORUS
fol. 172v *David as Victor*

The miniature shows King David in a statuesque pose, trampling on a horizontally prostrate monster with an animal head at either end. The long lance crosses his body diagonally, and with his lifted right hand he holds a ring inscribed with his name. The motif is repeated, as in the preceding miniature, in the form of dotted smaller circles scattered here over the entire background.

The broad frame is again divided into panels, larger and fewer than in the former miniature, with step patterns alternating with fine-strand interlace. The fact that the same type of frame recurs in the first miniature of the Apocalypse in Valenciennes, based on a cycle brought to Northumbria by Benedict Biscop, confirms the Jarrow origin of the manuscript.

In an almost exemplary way a comparison between the two miniatures makes it clear at first sight that they are by two different artists. In the standing David the voluminosity of the seated David has disappeared. The figure is firmly outlined by a thick black line, and the folds of the garments look as if they were incised on a flat board, leaving the indication of a protruding knee as a mere surface ornament. The geometrized outlines reach their optimum in the oval head which rises to a point with the hair rolling down in scroll-like curls. As so often in Insular art, all expression is concentrated in the fixed gaze of the wide-open eyes.

PLATE 29

THE TRIER GOSPELS
fol. 12 *Canon Table*

The twelve disciples who accompanied Saint Willibrord on his missionary expedition to the Frisians became the first monks in the abbey he founded in Echternach. Some of them were expert calligraphers trained in the Hiberno-Saxon style of writing and decoration, and they continued to practice this art in their new abode. There, they were joined by other scribes of a different formation, accounting for the fact that the Gospel Book produced for the cathedral of Trier, not far from Echternach, is partly in Insular style, written by a scribe who twice signed his name as Thomas, whereas part is by an anonymous monk with Merovingian training.

All the full-page miniatures of the Trier Gospels belong to the sections written by Thomas. Although at first glance they appear far from uniform in style, all, nevertheless, are by his hand. The diversity comes from the fact that he had two models. Apart from the Gospels of Saint Willibrord from which the inverted cross-frame of the Evangelist portrait at the beginning of Saint Matthew (not reproduced here) has been borrowed, the artist had at his disposal another, quite different, Gospel Book illuminated in a Byzantine style. These miniatures he tried to imitate as best he could, though not without now and then relapsing into his own idiom.

To these copies belong the Canon Tables with *imagines clipeatae* of the Apostles surmounting the arcades—a theme which probably goes back originally to a Greek archetype of the fourth century. I have tried to show elsewhere that a set of Apostle medallions adorned the mausoleum which Constantine the Great built for himself beside the Church of the Twelve Apostles in Constantinople, and that these inspired the introduction of the motif into the Greek archetype of the Canon Tables. The placement of the medallions on top of arches is, however, a Latin innovation.

90

PLATE 30

THE TRIER GOSPELS
fol. 10 *Two Archangels with Title Tablet*

The miniature, still retaining the almost square format of its prototype, is placed
before the Canon Tables, although the text on the tablet held by the two Archangels
announces the beginning of the Gospel *secundum Mattheum*. The tablet is at the
same time supported by a column with a capital that has been transformed into a
typical Insular plaited linear ornament. The composition as a whole is taken over
from a Constantinian coin where two Victories are seen flanking a shield on top of
a column with the *vota* inscription in honor of the emperor. The coloristic back-
ground suggesting the contour of the landscape is another sign of the dependence
of the miniature on an early archetype.

The Archangels Michael and Gabriel carry long staffs, inappropriately provided
with round knobs at either end. They are dressed in pink mantles wrapped over a
light blue tunic with yellow *clavi*. The style reflects the immediate model of the
Echternach painter, which must have been an Italian work of the sixth or seventh
century—perhaps a present to Saint Willibrord from the Pope who ordained him
in Rome as Archbishop of Utrecht. The knotted finials forming diagonal pairs at
the corners of the frame are a contribution of the painter's native art.

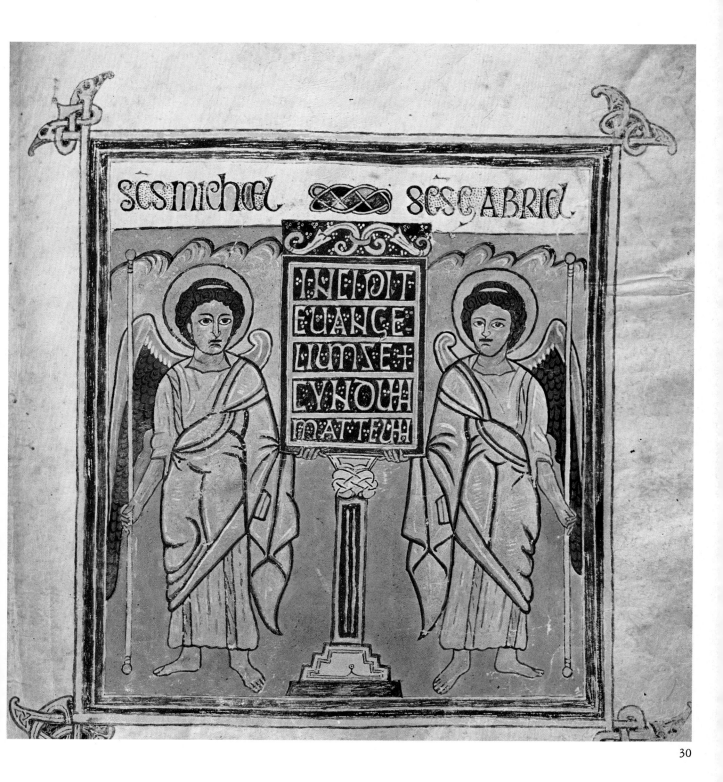

30

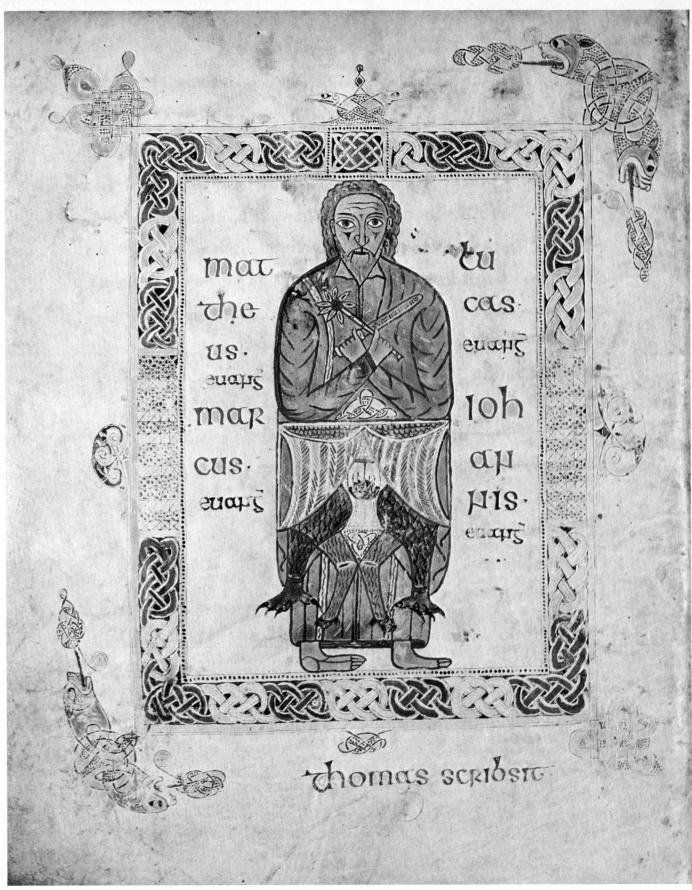

mat
the
us.
euang
mar
cus.
euang

tu
cas
euang
ioh
an
nis
euang

thomas scribsit

PLATE 31

THE TRIER GOSPELS
fol. 5v *The Tetramorph*

On a page facing Saint Jerome's prologue to his new translation of the Gospels is
a strange miniature in a heavy Hiberno-Saxon frame, with the usual excrescences
in the corners corresponding symmetrically on the diagonal. It encloses a figure with
both feet turned right, like Saint Matthew's symbol in the Book of Durrow (Plate
4). His arms are crossed at chest height, holding a flower scepter and what looks
like a ceremonial knife, also crossed, in what has been called "the Osiris pose."
Under the straight line of his waist, attached like a triple apron, hang the hind-
quarters of the symbols of Mark, Luke and John—the Lion, the Calf, and the
Eagle—while the figure himself is a full-length representation of Matthew's
symbol, the Man.

Unlike other symbolic representations of the intrinsic unity of the Gospels, where
all four symbols are given equal importance, here that of Matthew takes pref-
erence, and the other three are treated as appendices, attached as they are to Man's
body in parts only. It so happens that we know that before Eusebius arrived at a
definitive solution for a concordance of the Gospels in his Canon Tables, a Gospel
harmony existed, composed by Ammonius of Alexandria, consisting of the full
text of Matthew and those passages of the other Gospels that were in agreement
with it. Apparently the miniature is an illustration to his system.

The primitivism of the representation makes it unlikely that it was taken over
from the Gospel Book that contained the Archangels and the Canon Tables. More
probably it is a free invention of the Echternach artist who signed it, at the bottom
of the page, with the characteristic addition not of *pinxit* but *scribsit*.

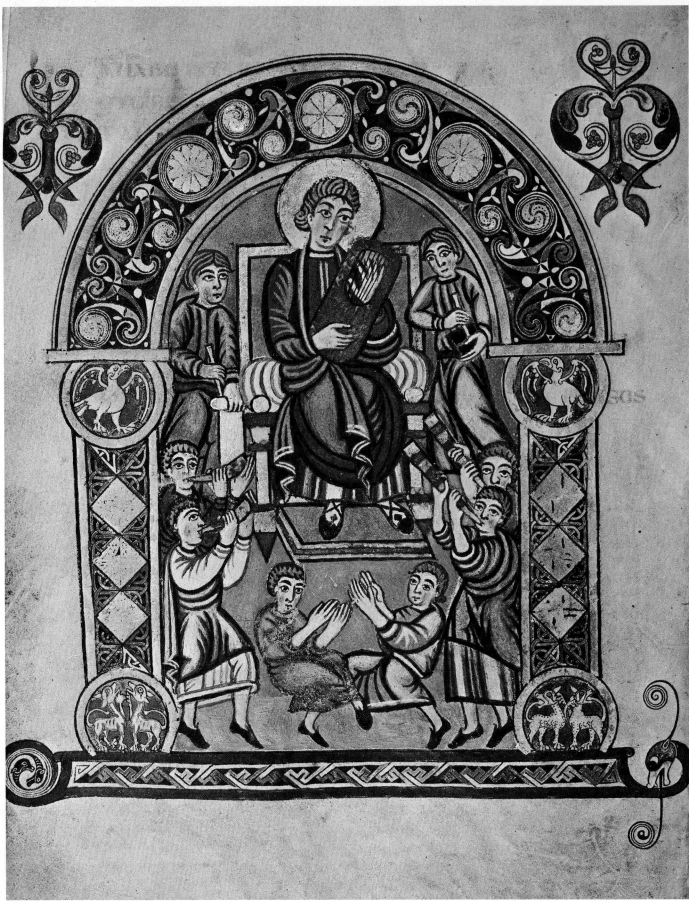

PLATE 32

THE CANTERBURY PSALTER
fol. 30v *David Composing the Psalms*

The illuminated manuscripts brought to Canterbury by the Gregorian mission—the Gospel Book in Corpus Christi College Library 286 seems to be the only survivor —remained a neglected source of inspiration for more than a hundred years. It was not until the second quarter of the eighth century that, under the stimulating influence of Hiberno-Saxon book illumination in the north, they became the basis for a new trend in manuscript production which raised the monastery of Saint Augustine to a leading place in pre-Carolingian art.

Among the earliest examples of this revival is the Vespasian Psalter in the British Library. We know from Thomas of Elmham, who was a monk at Saint Augustine's in the early fifteenth century, that it was kept over the high altar, together with five other manuscripts believed to have belonged to the patron saint of the abbey.

The frontispiece, now wrongly placed at the beginning of Psalm 26, shows the youthful king, distinguished by a golden halo, enthroned in the upper part of the picture. He plays a lyrelike harp, constructed like the instrument in the Durham Cassiodorus (Plate 27), plucking the strings with his right hand and stopping them from behind with the spread fingers of his left. He is flanked by two *notarii* taking down his song and words on a writing diptych and a scroll. Four musicians blowing trumpets and two dancers clapping their hands form a ring before him.

The scene is enacted within an arcade with ornamental fillings of scrollwork, interlace and key patterns. Instead of capitals and bases, the vertical supports have three-quarter medallions in which eagles with spread wings and affronted lions are depicted. Prototypes rather than copies of similar inserts in Merovingian manuscripts, they probably owe their origin to Oriental textiles. From the same source are derived the foliate shrubs in the spandrels on either side of the arch.

The border at the base adds to the liveliness of the miniature, ending as it does on one side in a whirl and on the other in the head of an animal with tongue and ear-tufts extending into antennaelike spiral terminals.

PLATE 33

THE CANTERBURY CODEX AUREUS
fol. 16 *Purple Page with Inlaid Crosses*

This manuscript is an example of the survival of the ancient technique of dyeing parchment purple. Half of the leaves have been treated in this way, whereas the other half are untinted. A variety of inks—gold, silver and white on the purple pages, black and red on the others—add to the rich coloristic effect of the leaves. The effect is heightened by many pages having geometric or emblematic patterns inserted into the script and also drawn in different inks.

Certain of these patterns are close to the *carmina figurata* written by Publilius Optatianus Porfyrius for his patron Constantine the Great, using gold and silver ink on purple parchment. We happen to know that a copy of his 'crossword' poems was available in England around the middle of the eighth century. In a letter written shortly after the death of Saint Boniface in 755 A.D. to Lullus, his successor in the See of Mainz, Bishop Milret of Worchester mentions it as lent to Cuthbert, Archbishop of Canterbury, who died in 758. Very likely, then, the Stockholm Gospels were written in the 750's.

A manuscript of royal splendor, the Codex Aureus might well have been produced at the expense of a king, and if so, most probably Aethelbald of Mercia, who at this time had extended his power to Kent. He is known as a benefactor of Christ Church Cathedral of Canterbury and as friend to Archbishop Cuthbert.

HABUNDAUE RITIUSTI
TIAUES TRA PLUSQUA
SCRIBA RU ETPHARI
SACORU NO NINTRABI
TIS IN RGNA NAC ET
RTAUDIS TISQ UIADICTU
ESTANTI QU ISNO NOC
CIDES Q AU TEM OCCI
DERIT RE ERIT IUDI
CIOEGO AUT DICOUO
BISQUIA OM NISQUI
IRASCIT UR FRATRISUO
REUSERIT IUDICIOQU
AUTEDIXER ITFRATRI
SUORA CHA REUSERI
CONCILIO QUIAUTE
DIXERIT FA TUEREUS
ERITGE HEN NACIGNIS
SIERGO OFF ERESMUN
USTUM AD ALTARET
IBIRECO RD O XPSFUE
RISQUIA FR ATERTUUS
HABETA LI QUIDADUER
SUTERE LIN QIBMUNU
NUSTU UA NTEALTA
RE ETUA DEP RIUS

RECON CIL IARETRA
TRITUO ET UNCUENI
ENSOFFE RS MUNUS
TUUES TCO NSENTI
ENS AD UERSA RIOTU O
CITO DUESINUACUEO
NE FORTETR ADATO
UERSARIUS IUDICI ET
IUDEXTRA DETTEMINIS
TROINCARCE RECITTA
RISAMEN NON COTIBINO
EXIESIN DE DONGCRED
DASNOUIS SIMU QU
ADRAN TE AUDIS TIS QUIADIC
TUESTANTI QUISNON
MOECHABE RISEGOAU
TEDICO UOB ISQUIAOM
NISQUI UIDO ERITMU
LIEREXOD CO NCUPISCEN
DAEAMIA M OECHATUS
ESTEAIN CO ROESUO
QUODSTO CU LUSTUUS
DEXTER SCANDALIZA
TECRUE ER UETPRO
ICEABS TEE XPODIT

PLATE 34

THE CANTERBURY CODEX AUREUS
fol. 5 *Canon Table*

With some aberrations in their distribution the eight surviving pages, comprising Canons I to VIII, follow the normal twelve-page set of Saint Jerome. They are laid out on two double leaves, each painted by a different artist. Painter A, who worked on fols. 5 and 8, provides his arcades with architectonic bases and capitals. These are replaced by painter B, on fols. 6 and 7, with medallions (Plate 35).

In their heavy proportions all the Canon Tables are very different from the slender arcades of the Book of Lindisfarne (Plate 16). The table reproduced here reminds us in its scrollwork of the frame of the David miniature in the Vespasian Psalter (Plate 32). In fact, the resemblance is so close that we should identify painter A with the Psalter master.

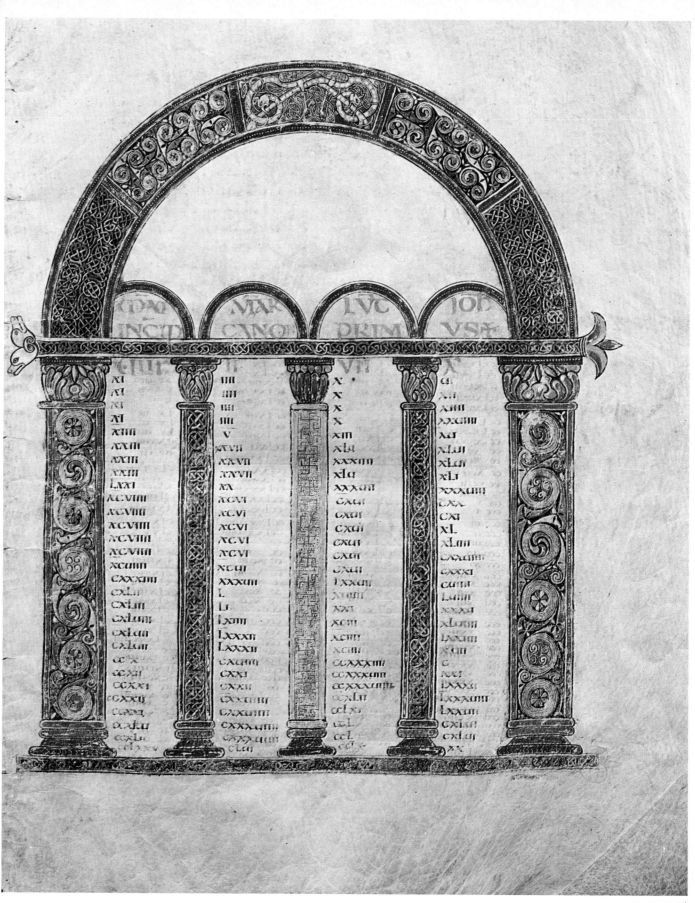

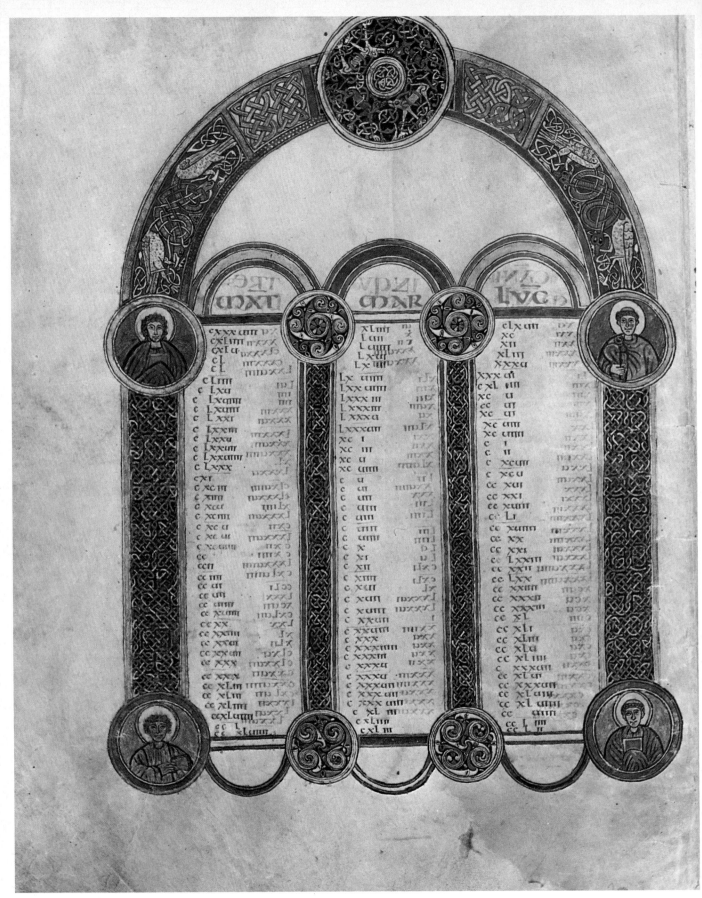

PLATE 35

THE CANTERBURY CODEX AUREUS
fol. 6v *Canon Table*

The second artist of the Canon Tables, painter B, has deprived his arcades of their architectonic character by introducing medallions—larger at the outsides and smaller between—at the top and bottom of all the vertical members. Where the Trier Gospels have the *imagines clipeatae* of the Apostles at the top of the arch, painter B places a particularly grand medallion, like one of the disc brooches that were the pride of the pagan Kentish goldsmiths during the sixth and seventh centuries.

The smaller medallions in the middle of the arcade have scrollwork in imitation of the escutcheons on the hanging bowls. The four medallions of the outer columns contain busts of saints holding a book or a cross, no doubt representing confessors or martyrs whose relics Canterbury owned. Similar, decoratively used medallions with busts occur frequently in monumental painting.

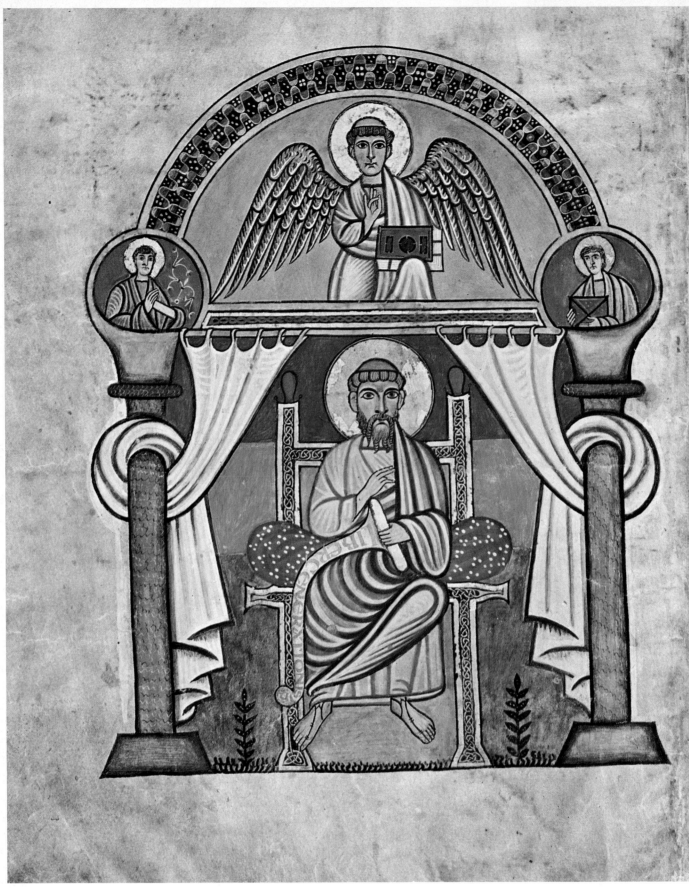

36

PLATE 36

The Canterbury Codex Aureus
fol. 9v *Portrait of Saint Matthew*

Only two Evangelist portraits survive in the Stockholm Golden Gospels. In accordance with the composition of the Evangelist portrait in the Corpus Christi College Gospels sent to England with Saint Augustine, they show the holy author solemnly enthroned within an arcade, with the symbol, a half-length figure, included in the tympanon.

In comparison with the older Hiberno-Saxon Evangelists, both miniatures demonstrate a definite advance in the conquest of three-dimensional space. The massive columns carry bonelike capitals, and two heavy curtains wind in mighty curves around their shafts; drawn aside, they expose the holy author against a background divided into three zones of blue deepening as they rise. Separated from it by the flat laths of the throne framing a yellow foil, the figures almost seem to float in a space in front of the foreground. With their tonsured heads set against golden haloes, they eye us steadfastly, conscious of the gravity of their mission.

In the portrait of Saint Matthew, the stylized shieldlike flap over the left knee and the crescent-shaped folds beside it still preserve a connection with the drapery style of the Durham Crucifixion (Plate 14) and the portrait of Saint Mark in the Gospels of Saint Chad (Plate 24); otherwise, the figures both of the Evangelist and of his symbol, are closer to the plastic style of Italo-Byzantine art. The throne adds to the stature of the Evangelist, by rising to the level of his head. The upward surge is increased by crowning the columns with smaller half-length figures of saints, framed by the capitals forming a curved "horn" around them. These figures show a strong family likeness in the design of their countenances to the figures in the Vespasian Psalter, where the framing arch is by the same artist A as the Canon Tables on fols. 5 and 8. It is probable that he was also the painter of this portrait of Saint Matthew.

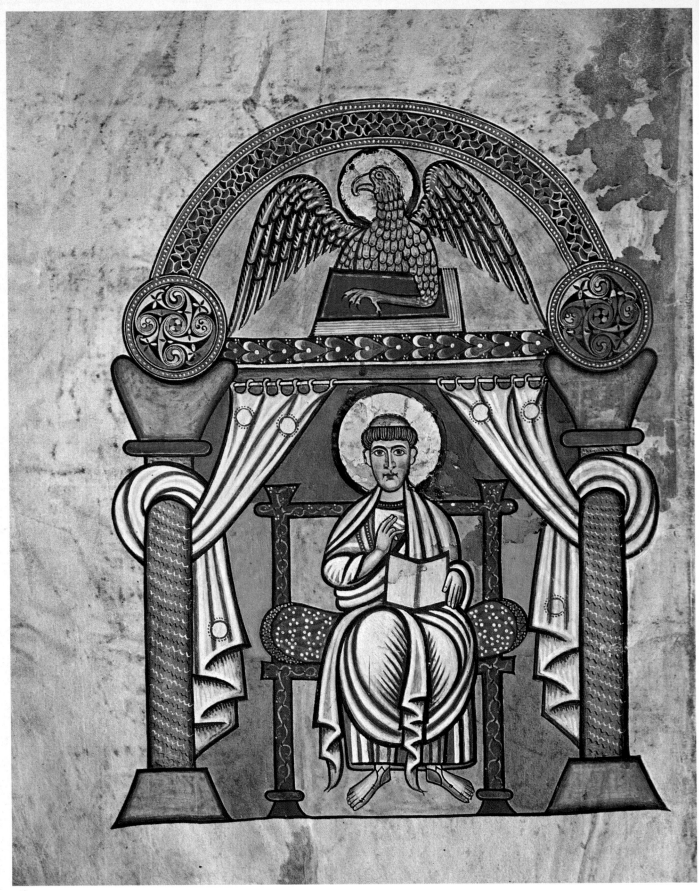

PLATE 37

THE CANTERBURY CODEX AUREUS
fol. 150v *Portrait of Saint John*

Although similar in arrangement to the former miniature, the portrait of the fourth Evangelist is undoubtedly by another painter. The difference between the two is particularly striking in the design of the throne; instead of the high and narrow proportions of the first miniature, it is widened laterally, leaving the figure isolated in its midst. The painter has emphasized the roundness of the forms in the design of Saint John's mantle, particularly in the bulging lower part where the drapery repeats King David's in the London Psalter (Plate 32). The fact that the white tones dominate in the garments of Saint John, as opposed to the pink and blue in Saint Matthew's tunic and mantle, has the effect of making the curtains frame the Evangelist, rather than carrying the eyes up to the symbol as in the Saint Matthew picture.

The two discs on top of the columns have a filling of scroll and trumpet patterns so close to those in the Canon Table fol. 6v that it seems likely that this miniature was painted by artist B, just as the portrait of Saint Matthew is by the other painter, A.

106

PLATE 38

THE CANTERBURY CODEX AUREUS
fol. 11 *The Incarnation Initial*

The grand full-page initial of the Irish-Northumbrian Gospel Books has been replaced by a smaller *Chi*, followed by seven rows of capitals. These fancy capitals are set like inscriptions within horizontal panels, alternately varicolored on a gold ground, or golden themselves on bare parchment with a colored strip down the middle.

Occupying the height of two panels, the *X* still dominates the page. Symmetrical in shape and fillings, its shafts end on one side in solid whirls and on the other in two animal heads in gold, seen from above. Lifted, as it were, by the seething scrollwork below and between the left shafts, the initial cuts the upper line of the frame, bending down towards the enclosed initials *P* and *I* and the fancy capitals. Between them are fine-meshed interlace or rinceaux fillings, enlivened here and there by animals.

The relationship of these animals to their appendages is similar to that of the lions in two of the panels of the Harping David miniature in the Durham Cassiodorus (Plate 27). Among them are two curious little creatures of a new type, one looking like a lizard seen from the back, the other rendered *en face* in the position of a squatting squirrel.

A long note in the margin states in Anglo-Saxon that the book was redeemed with pure gold and restored to Christ Church Cathedral by Aelfred, the Earl, and Weburgh, his wife, who are known from another late ninth century document. An interesting example of the blackmailing methods used by the Vikings!

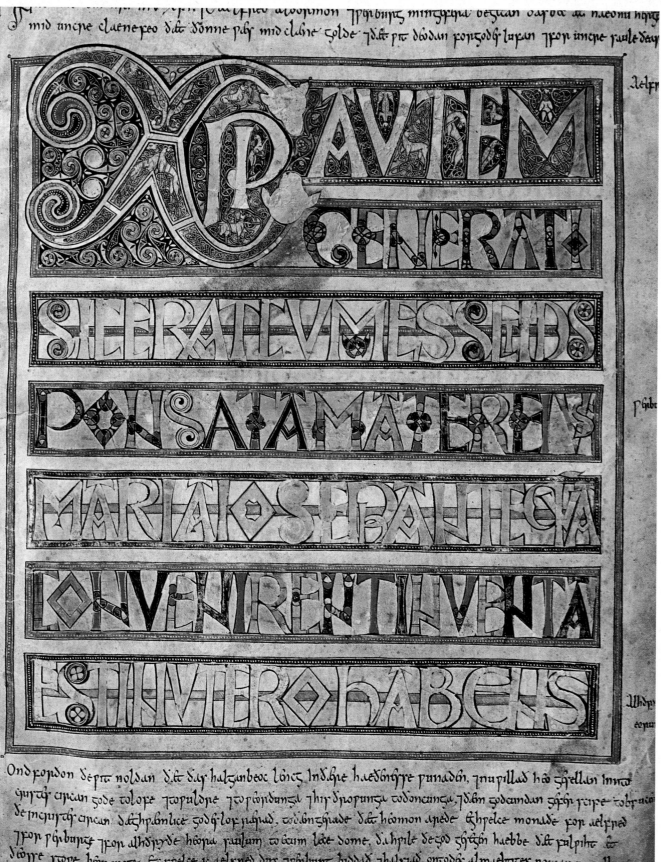

XPAVTEM
GENERATI

SICERATVMESSETDS
PONSATAMATEREI9
MARIAIOSEBANTESA
CONVENIRENTINVENTA
ESTINVTEROHABEHS

Ælꝼ

⁊habe

uðɲe
eopɲ

Ond ꝼoɲðon ðepɲ noldan ðæt ðaɲ haꞇɡanbeoc lóoer, Indhie hæðennrɲe punaðen, ⁊nupillað heo ɡꝺellen Innꞇo
cuɲꞇ cipean ɡoɗe ꞇoloꝼe ⁊ꞇopulðpe ⁊ꞇopondunɡa ⁊hir ðpopunɡa ꞇoðoncinɡa, ⁊ðæn ɡoðandan ɡæꝼi ꝛeiꝼe ꞇobɲuco
ðe mcnuɲꞇ cipean ðæꞇhplonlice ɡoðh ꝼoɲ uꝼhad. ꞇoðonɡhiade ðæꞇ héo mon apeðe. Æhpelce monaðe ꝼon aelꝼɲeð
⁊ꝼoɲ ꝛhibuɲꝛ ⁊ꝼoɲ alhðɲyðe héopa ꝛaulum ꞇobeim læc dome. ðahpile ðeɡoð ɡꝺæꝺn hæbbe ðæt ꝛulpiht te
ðóꝛꝛe ꝛope bóon moꞇe., Eppelee ic aelꝼɲeð duⲭ. ⁊ꝛhibuɲꝛ biddað ⁊halꝛiad onɡoðꝛ almæhꞇiɡeɲ noman ⁊on allꝛu
hiɲ haliɡɲu ðæt nbuꞇɡmón ꝛeo ꞇoðon ɡðyꝛꞇꝛ. ðæt ðiꞇ haꞇɡan bloc ꞇꝛelle oðbe uðꝺóde ꝼnom cuⲭꝺꝼ cipean. ðahpile

PLATE 39

THE BOOK OF KELLS
fol. 183v *Text Page with Initials*

"The great Gospel of Columkille, the chief relic of the Western world," as the
Book of Kells is called in the Annals of Ulster, holds a unique place in the history
of Hiberno-Saxon illumination because of its extraordinary wealth of decoration. The
full-page miniatures are more numerous and more densely decorated than in any
other manuscript; in addition, practically all the text pages are studded with initials,
large and small, sometimes also with animals and other motifs as line fillers.
Remarkable for their time, the twelfth century, are the words of Giraldus de Barri
about a deluxe manuscript shown to him in Ireland, possibly the Book of Kells
itself, or, in any case, fully applicable to it: "Examine it carefully, and you will
penetrate to the very shrine of art. You will make out intricacies so delicate and
subtle, so concise and compact, so full of knots and links, with colors so fresh and
vivid, that you might think all this was the work of an angel, not of a man."

Various opinions have been expressed as to when and where this manuscript was
produced. Several scholars have opted for Iona, including A. M. Friend, who
discovered the close resemblance between the Canon Tables in the Book of Kells
and those in two Gospels produced at the Court School of Charlemagne about the
turn of the eighth century. In fact, it seems to have been the splendor of such an
imperial model that stimulated the unusually rich decoration of the Book of Kells.
This calls for a dating of the manuscript in the years preceding the final attack on
Iona by the Vikings in 807 A.D., when the monks were forced to move to Ireland.

The text of the Book of Kells, usually written in seventeen long lines a page,
is a perfect example of Hiberno-Saxon majuscule script at its best. Apart from the

chapter list to Saint John and the list of Hebrew names at the beginning of the manuscript in various colored inks and a more fanciful type of script, the text on the whole is so uniform as to the shape of the individual letters that it is difficult to ascertain whether one or several scribes were responsible for it.

The text initials are usually placed at the beginning of a new verse or section, but now and then they also appear in the middle of the text column. In either case their connection with the text lines is so intimate and so well calculated that they must have been planned and drawn by the scribe himself, as was usually the case in Hiberno-Saxon manuscripts. In many instances it even seems evident that they were completed before the following text had been written, so that we may imagine the calligrapher switching back and forth as he worked, from pen and ink to brush and color.

Two types of initials may be distinguished: one, like the second initial from the bottom in the page reproduced here, an enlarged fancy letter in black with colored interstices or appendices; the other in full color with a more diverse repertoire of ornament, including animals and even human figures. Quite often they consist of two or more letters combined into a monogram, coupled then, if they are adjacent, like the two upper initials shown here. The most common of these monogram initials are those containing the word *Et,* of which there are three in this folio. Although there are more than four hundred in the whole manuscript, no two are exactly alike. The decorative inventiveness of the artist, or artists, is inexhaustible.

crucifixerunt eum & custodieba

nt eum

Erat titulus causae eius in

scriptus rex iudeorum

Cum eo crucifigunt duos la

trones unum adextris &

alium asinistris eius

Et adimpletaest scriptura

quaedicit Et cumininiquis de

putatus est

Praeter euntes blasphema

bant eum mouentes capita

sua Etdicentes uae quidistruittem

plum Ettrib: dieb: aedificat il

lud saluumte facipsum discen

dens decruce

Similiter summi sacerdotes

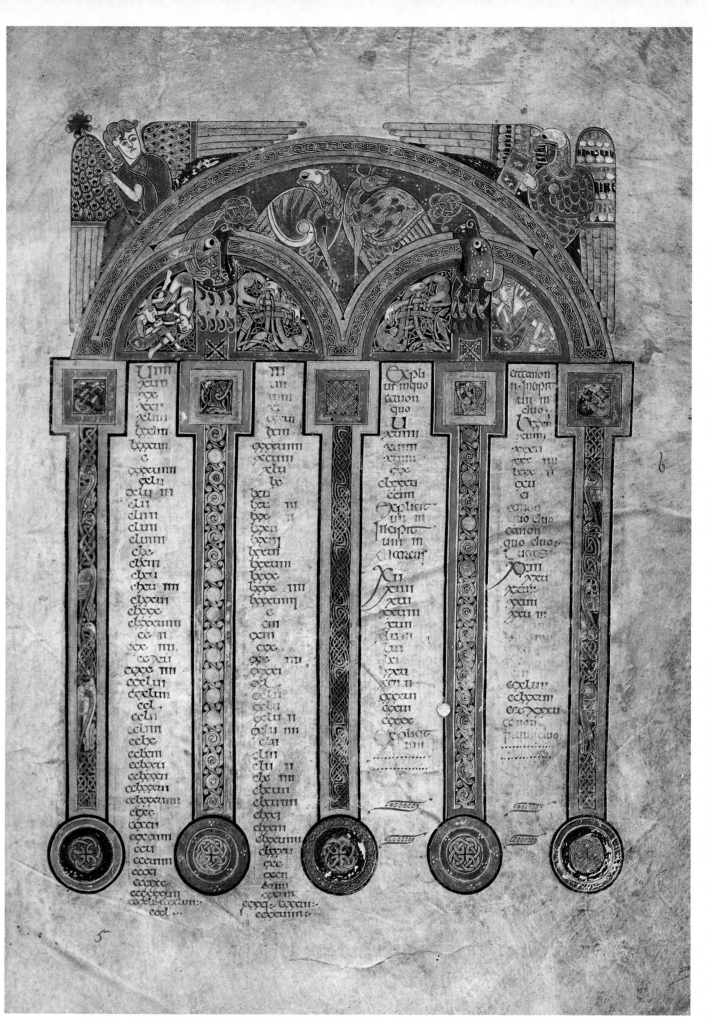

PLATE 40

THE BOOK OF KELLS
fol. 5 *Canon Table*

In the Book of Kells the *Canones evangeliorum* occupy ten pages, but as they are followed by two blanks, a normal twelve-page series must have been planned. A continental model of great splendor is reflected in the architectonic framework, the distinctive features of which are that the spandrels are closed by rectangular fillings and that full-length figures of the Evangelist symbols inhabit the tympanon. Both these characteristics can be matched, as A. M. Friend has shown, in two Gospel Books written and illuminated around the year 800 in the Court School of Charlemagne.

 The dependence upon a Court School model is most evident in the first four Canon Tables, after which a break in the system of the symbols occurs. In the Canon Table here reproduced, containing Canon VI to VIII, another earlier model, with two major arches cutting into the tympanon, has caused the painter to move two of the symbols out into the spandrels of the main arch, where they lend a rectangular form to the composition by the position of their wings. Liberated from the constraint of following the Carolingian model slavishly, the artist has created the most harmonious of the Canon Tables, finely balanced in its symmetrical structure.

PLATE 41

113

THE BOOK OF KELLS
fol.32v *Christ Attended by Angels*

The genealogical lists that open Saint Matthew's Gospel are followed by a full-length portrait of Christ, standing in a keyhole arch surrounded by a broad rectangular frame. Lacking a halo, but with a cross above his head, he holds a book in his covered left hand, touching it with his right. Although the figure looks as if he is standing, a cushion behind him cuts awkwardly into his body to the right, no doubt the remnant of a model where he was shown enthroned. On either side of his head are peacocks, symbols of immortality. Two pairs of angels fill the openings between the keyhole arch and the main border. One carries a leaf staff, another has his wings crossed in front like a seraph.

With long curly hair and staring eyes, the head of Christ resembles Saint Luke in the Gospels of Saint Chad (Plate 25). However, here the extreme flatness of the figure has been overcome by a new sense of plasticity, inflating the draperies as if they were filled with air.

PLATE 42

THE BOOK OF KELLS
fol. 33 *Carpet Page with Cross*

Split into a great number of firmly outlined panels, this carpet page features a double-armed cross like its counterpart in the Book of Durrow (Plate 2). Here, however, instead of squares, the cross is made up of medallions that reach out into the inner field of the framing border.

The six panels between the cross arms correspond symmetrically with regard to their fillings, those in the corners diagonally. The eight medallions, all filled with the same scrollwork pattern in black and white only, form an effective counterpoise to the dominating red and yellow tones of the page. A similar color contrast appears between the diminutive fret pattern in the corner squares of the frame and the bobbin-lace knots set between animal heads in the middle of each side.

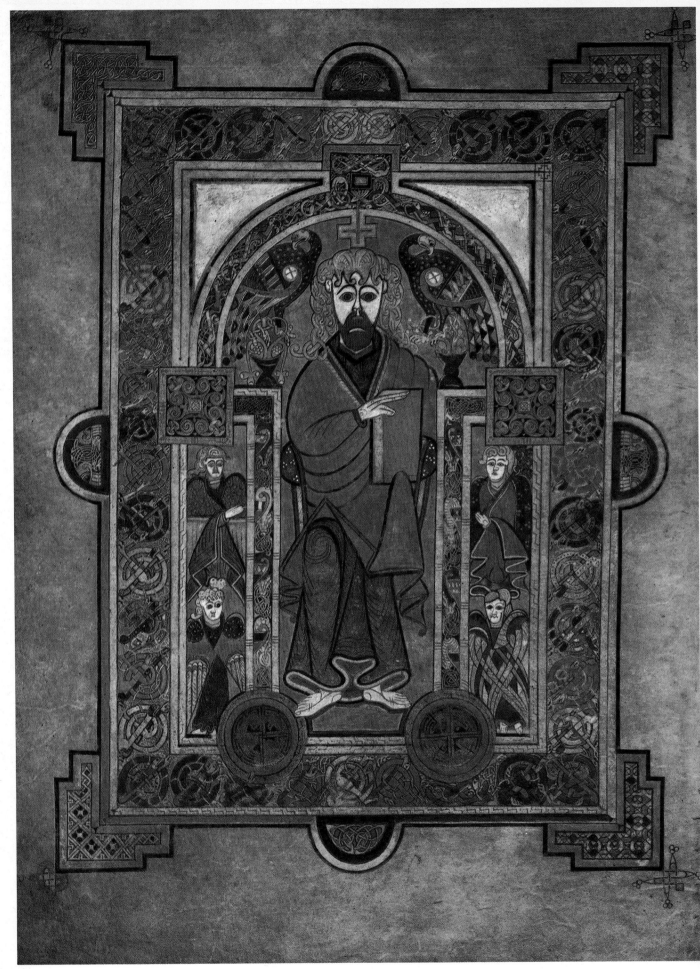

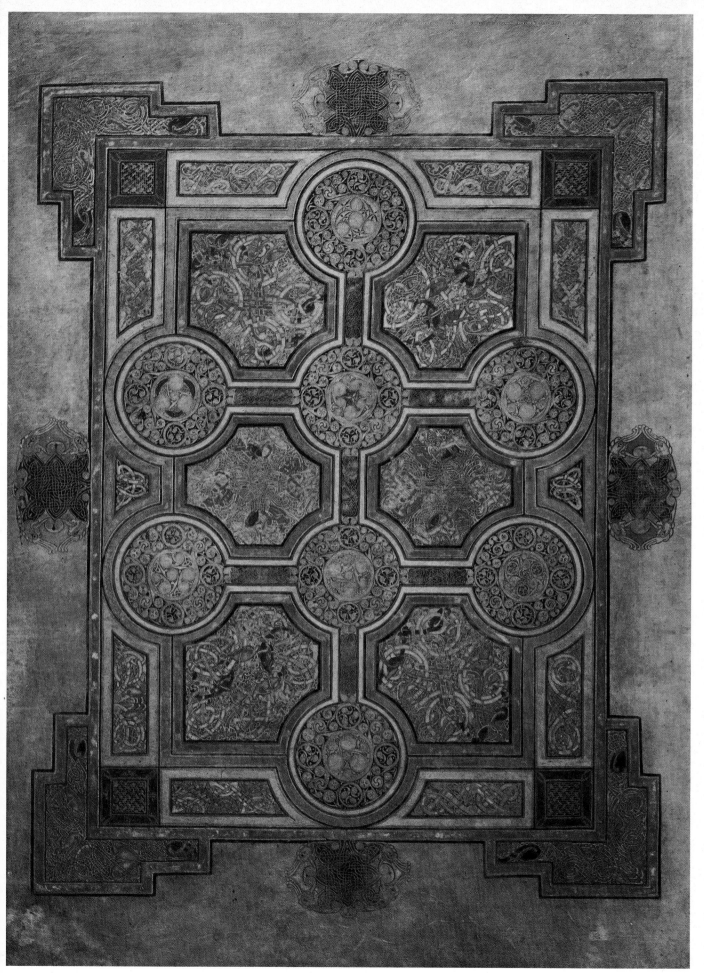

PLATE 43

THE BOOK OF KELLS
fol. 7v *Madonna Attended by Angels*

Opposite the first chapter list, beginning *Nativitas Domini* ("The birth of our Lord"), is a full page portrait of the Virgin and Child, seated on a high-backed throne seen in profile, and attended by four angels. Together with three semicircular protuberances, the figures cover the ground inside the frame as a coherent *opus interrasile* relief, leaving the white parchment visible only in isolated fragments.

The Virgin is dressed in an ample *maphorion,* covering an intimation of her hanging breasts. A yellow veil wraps her heavy head, and a thin, wrinkled, violet tunic covers her stunted legs. She holds the Child turned in a direction opposite to her own. Of the four angels, the two in the lower part peep up at her, as it were from behind the throne, whereas the other two raise their hands in a gesture pointing towards heaven. Three of them carry scepters ending in discs, too small to be flabella. The fourth grasps a plant with curving branches.

The complementary positions of the Virgin and the Child, seated in opposite directions, has a parallel in a more artless engraving of the same motif on the wooden reliquary casket of Saint Cuthbert in Durham. The Mediterranean model common to both was most probably a Byzantine icon; indications of this are the renderings of the halo of the Virgin as transparent, together with other vestiges of an illusionistic style.

The broad frame with a filling of animal interlace and stepped protrusions at the corners follows the design inaugurated by the Lindisfarne Gospels (Plate 19). On the right it is interrupted by a little compartment with the busts of six bearded men looking towards the opposite page, possibly a group of monks from the congregation to which the artist belonged. It should be noted that an early cult of the Madonna within the Columban order is attested by the hymn *De Beata Maria Virgine* ascribed to Saint Cuchuimnei who lived around 700 A.D. (*Analecta hymnica,* ed. C. Blume, No. 233).

PLATE 44

THE BOOK OF KELLS
fol. 34 *The Incarnation Initial*

Of all the pages in the Book of Kells, this is perhaps the most celebrated. The talismanic conception of the holy word underlying the development of the grand initials in the Hiberno-Saxon Gospels has here reached its most resounding expression in the huge size of the X and in the shimmering mass of ornament swirling around it like a cloud of incense.

Acting in concert with a partial frame in the lower right corner, the windmill-sails of the X embrace a thronging variety of scrollwork and interlace in which the smaller initials P and I, forming a monogram, are embedded, riveted to the page by a crosslet square.

In certain places minor areas have been set aside for figurative vignettes. Busts of three angels, one alone and a group of two, are set against the long descender of the X, and a little higher up there are two lifelike moths. At the foot of the crosslet square, an otter has caught a salmon on the right, and at the left, a little genre scene of two rats nibbling at a wafer is watched by two cats, apparently holding them by the tail and with two more mice perched on top of their backs. The animals are drawn with an acute observation, testifying to a love of nature that has parallels in Irish poetry at the time. They also call to mind the Lives of certain Hiberno-Saxon saints where some of the miracles are due to the behavior of animals acting as if sent by God. His alliance with even the humblest beings in his creation might explain the place granted them, so close to the sacred name of Christ, in this miniature.

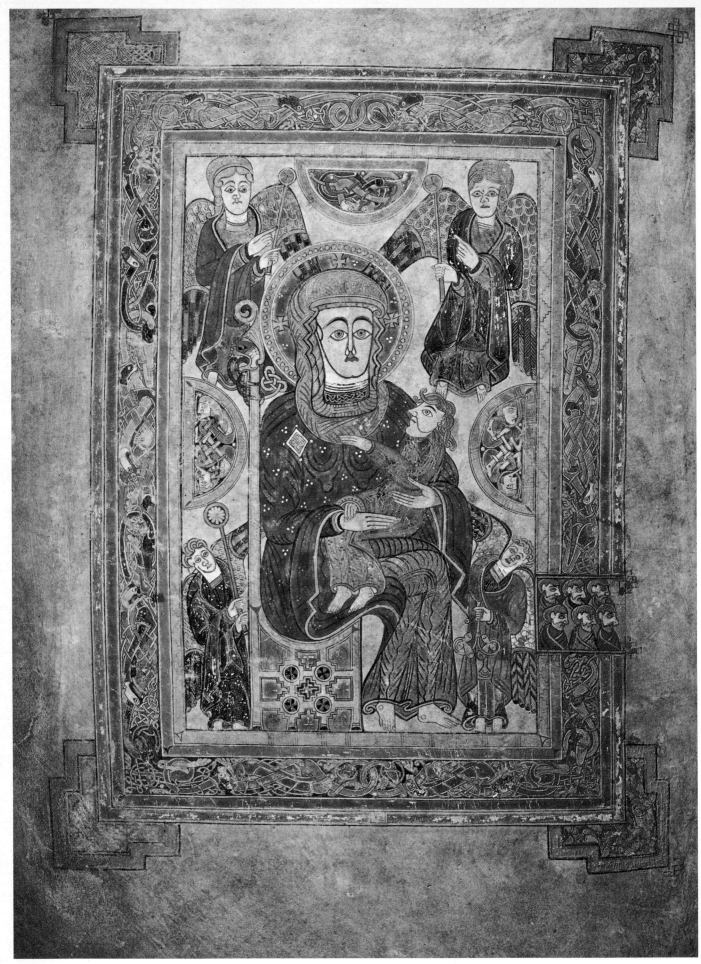

43

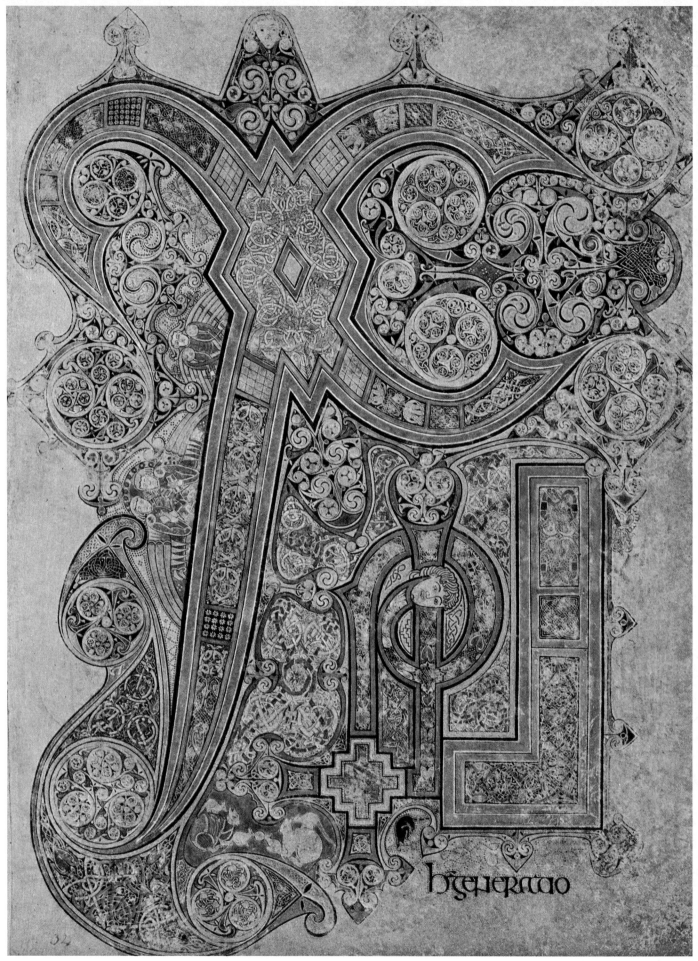

PLATE 45

THE BOOK OF KELLS
fol. 291v *Portrait of Saint John*

The Evangelist, with widespread legs and feet turned outward, is seated on a cushioned throne facing us frontally. To compensate for the lack of stateliness in his posture, the artist has provided the figure with a halo like a huge wheel, with three discs, filled by a pleated star pattern, set in a broad border of twisted animals surrounding an inner scalloped zone.

The white drapery covering the invisible back of the throne indicates that this miniature, like the "Beast Canons," depends upon a manuscript of the Court School of Charlemagne, where such thrones occur as a standard feature. From the same model the artist borrowed the motif of the Evangelist's right hand holding the huge pen as if he were dipping it, and the raised left hand carrying the Gospels.

Even more imposing than the huge halo is the rectangular border surrounding the Evangelist and almost overwhelming the miniature. In the center of each side is a crosslet square and set behind and emerging from them a pair of feet, two hands and a nimbed head (unfortunately maimed by the binder's knife), introducing a strange animation to the framework, comparable in principle to the device of ending a border in the hindquarters and head of an animal. In view of this, it does not seem necessary to interpret the motif symbolically as an image of Christ embracing the Universe.

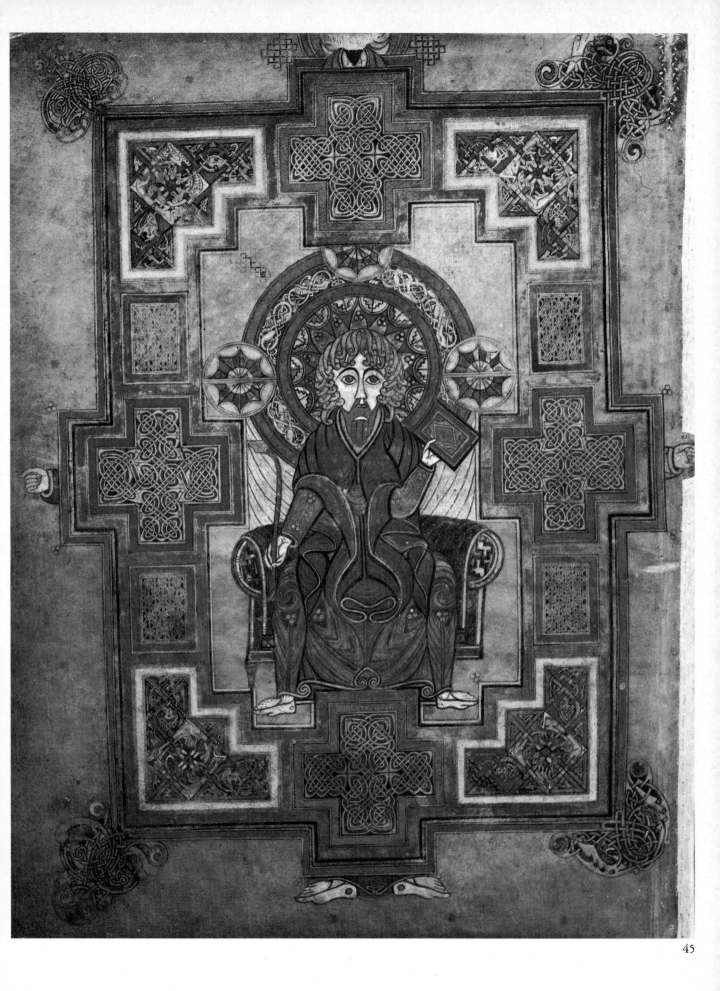

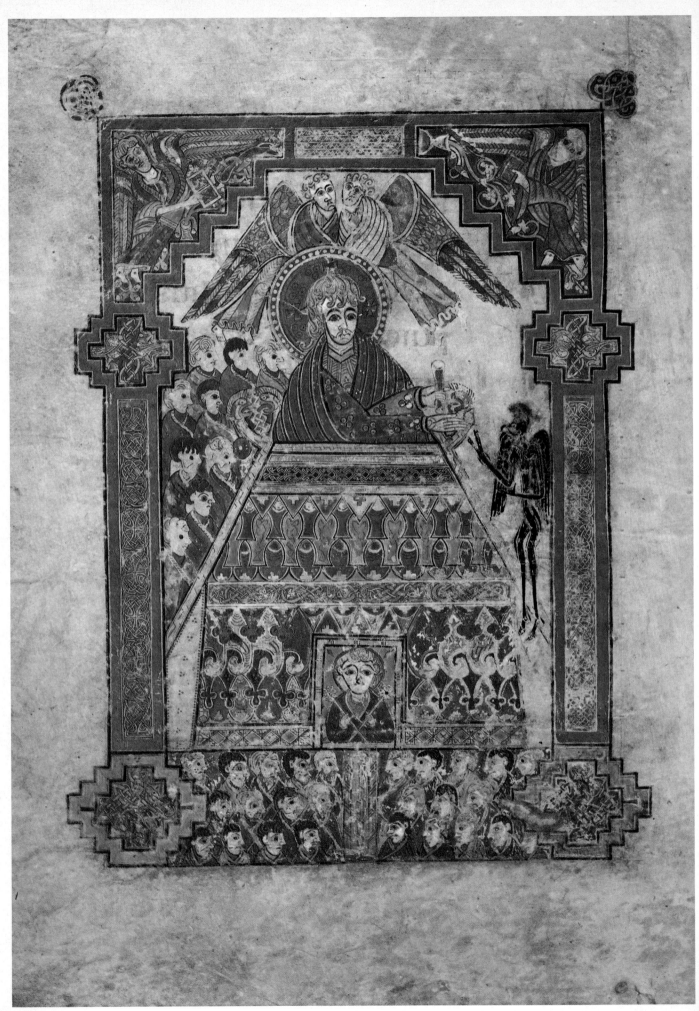

46

PLATE 46

THE BOOK OF KELLS
fol. 202v *The Temptation of Christ*

The subject of the miniature is one of Christ's temptations by the Devil, the third according to Saint Luke, when he refused to prove his divinity by throwing himself from the pinnacle of the temple.

Jesus, characterized as a young man, is shown in half-length crowning a church-like building densely ornamented with walls and high slanting roof covered by ceramiclike patterns, not unlike an Irish reliquary shrine. His hands, one holding a scroll, are stretched out in a teaching gesture towards the Devil, an emaciated black elf with wings. Above Christ's head two angels keep watch; another pair carrying books are located in the triangular compartments at the top of the frame.

It is usual to depict Christ as a full-length figure standing on the roof of the temple. The iconography chosen by the Kells artist is matched only in two late tenth-century Reichenau Gospels of Otto III, now in Aachen and Munich. But it seems that Prudentius also had the same formula in mind when in his *Dittochaeum* he included a poem referring to the scene shown here. Quoting Matthew 21:42, in which Christ compares himself to the corner stone which the builders had rejected, he tries to carry the simile still further by saying that after the destruction of the old temple, the corner stone now crowns the new temple as its keystone: "Now it is head of the temple and holds the new stones together."

In the central door of the temple appears a figure carrying two crossed flower scepters in the Osiris pose, most likely Christ having successfully withstood the Devil's temptation.

The miniature can be ascribed to the same artist who painted the Madonna (Plate 43). As in that picture rows of profile heads have beeen added, some old with beards, others young and beardless, assembled in three ranks on either side of a partition in the bottom section and in a group of nine behind Christ. It is hard to find a better explanation for them than that they may represent the inhabitants of the monastery in which the book was made, firmly resolved to resist, like Christ, the temptations of his world.

PLATE 47

T<small>HE</small> B<small>OOK OF</small> K<small>ELLS</small>
fol. 114 *The Arrest of Christ*

Under an arch, built up of separate panels of different shapes and joined by two lion heads with interlaced tongues snarling at each other, the scene is enacted by three figures: Christ, a giant wrestler, in the center, flanked by two red-haired menials shown in profile, who grasp his thin bare arms, holding them in a "hands-up" position as they arrest them. Naively illustrating the phrase *manum inicere* ("to lay hands on"), the one to the right puts his hand on Christ's body.

In approaching Christ from behind, the two guards seem to lift him out of the picture. At the same time, the strict symmetry of the group petrifies the action, as if time had come to a standstill. Nevertheless, the expressive power of the picture is overwhelming—a presage, it would seem, of the horrors awaiting the monks with the approaching attack by the Vikings.

The miniature has inscribed in the tympanum the first word of Matthew 26:30: "After reciting a hymn, they went out to Mount Olivet." The sentence, which only sets the stage for the scene, is enclosed between two plants growing out of vaselike roots, no doubt suggesting the garden of Gethsemane. From the description in Adamnán's *De locis sanctis,* the artist would have known that the Mount of Olives was clothed only in olives and vines, and this the creeping growth of the rinceaux forms of the plants no doubt illustrates.

The peculiar green color in this miniature relates it to the Temptation (Plate 46) and the Madonna (Plate 43). On the other hand, the head of Christ is strikingly similar to the portraits of Christ and the Evangelist (Plates 41 and 45).

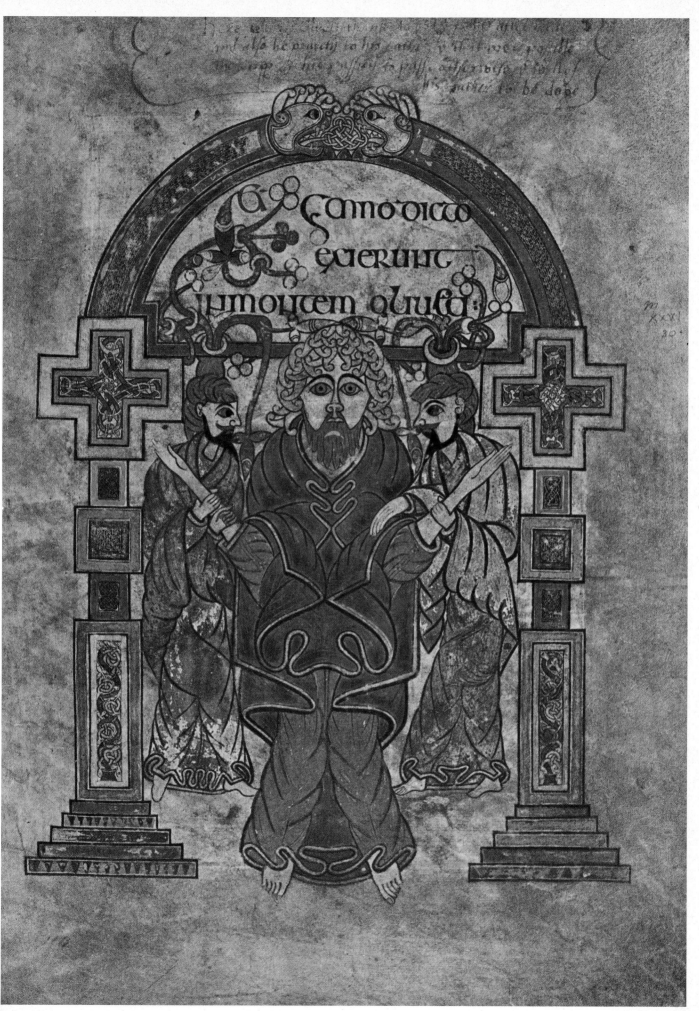

PLATE 48

THE BOOK OF MULLING
p. 193 *Portrait of Saint John*

Beside the splendid Gospel Books, written and decorated in a grand manner to
be placed on the altar, there existed a smaller type of "pocket" Gospel for personal
use, written out of economy in a smaller minuscule verging on cursive and filled
with abbreviations. Eight such manuscripts are known, all of Irish provenance.

One of them from the monastery founded by Saint Moling has a colophon
stating: *nomen h(uius) scriptoris mulling dicitur* ("the name of the scribe is
Mulling"). He cannot have been the saint himself, who died in 698 A.D., for
the manuscript must without question be dated a century later. It is possible that
the colophon was taken over from the exemplar, as so often in Irish manuscripts.

Three portraits of Evangelists are today assembled at the end of the book. Orig-
inally, however, they were placed, together with a lost fourth, at the beginning of
each Gospel. The one reproduced here has been identified as coming from the
Gospel of Saint John.

Standing with his legs wide apart, the Evangelist holds a square book with both
hands. His mantle is twisted in tubular flaps around his arms in a style reminiscent
of the Book of Kells. As in the miniatures of the other pocket Gospel Books, the
figure is set tightly between two vertical borders with animal interlace and corner
squares of fine-threaded interlace. The halo cuts the frame, pushing the figure
forward. The saint's "archaic" smile is unusual, but his fixed gaze is the normal
way of creating a contact with the spectator.

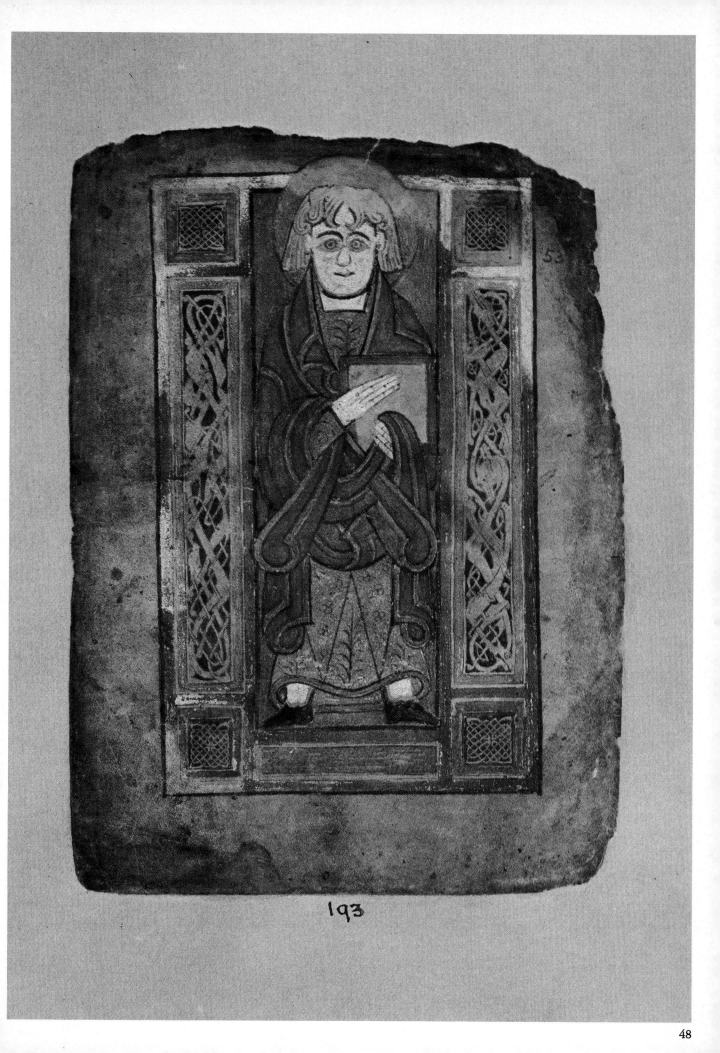